THE IMPRESSIONIST

ART BOOK

THE IMPRESSIONIST

ART BOOK

Discover 32 glorious paintings by the great Impressionist artists

Wenda O'Reilly, Ph.D.

with Ahna O'Reilly, Noelle O'Reilly, Mariele O'Reilly, Erin Kravitz,
Diana Howard and Tara Austen Weaver

BIRDCAGE BOOKS

Palo Alto

Acknowledgements

My heartfelt thanks and congratulations to Ahna, Noelle and Mariele O'Reilly and Erin Kravitz, for their superb editorial work. They took time after school and on weekends to help select the works of art to be included, and to review and critique every paragraph in the book.

My special thanks to Diana Howard for her creative partnership in every aspect of the project and to Tara Austen Weaver for her excellent research and writing. And many thanks to Victoria Alden, Susan Brady, Jill Bullitt, Chantal Declève, Krista Holmstrom, Gary Kray, Kathleen Meengs, Sean O'Reilly, Susana Sosa, Palmer and Dorothy Smith, and everyone at Travelers' Tales for their help and encouragement.

My young assistant editors and I would particularly like to express our appreciation to the Pacific Art League of Palo Alto for the many ways they have supported artists and fostered a love of art in our community.

Finally, I would like to give very special thanks to Maureen, Kerry, and Katherine Kravitz, Harriet Bullitt, and James O'Reilly, for their endless supply of creative ideas, enthusiasm, love and support.

For information, contact Birdcage Books, 2310 Bowdoin Street, Palo Alto, CA 94306.

www.BirdcageBooks.com

Cover and interior design: Diana Howard

Library of Congress Cataloging-in-Publication Data

O'Reilly, Wenda Brewster.
 The impressionist art book : discover 32 glorious paintings by the great impressionist artists / Wenda O'Reilly with Ahna O'Reilly [et al.].
 p. cm.
 Includes bibliographical references and index.
 ISBN 1-889613-05-3
 1. Impressionism (Art)—France. I. O'Reilly, Ahna, 1984- II. Title.
 ND547.5.I4 O74 2001
 759.05'4—dc21 2001035630

Distributed by Publishers Group West
1700 Fourth Street, Berkeley, CA 94710 USA • (800) 788-3123
FIRST EDITION
10 9 8 7 6 5 4 3 2 1
PRINTED IN HONG KONG

Table of Contents

The Impressionists were a group of artists who lived in or near Paris in the 1800's. They were friends who painted side by side and posed for one another. They lingered over long meals together, debating about art and life, and encouraged each other in big and small ways. The ones with money helped the ones who were poor. Together, they created an art revolution.

Industrial Revolution

Imagine living in a world without any machines — no cars, airplanes, bicycles, telephones, radios, recorded music — not even electric lights. That's the world into which the Impressionists were born. Yet within the span of their lifetimes, all of these things were invented. This was the period of the Industrial Revolution when, for the first time in history, machines did the work that had been done by hand and new inventions radically changed the way people lived their daily lives.

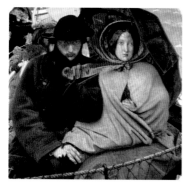

People on the move

Before the Industrial Revolution, families lived in the same place for generations, and children grew up to do what their parents did. In the 1800's, that began to change. With steamships and railroads, travel became easier. Huge numbers of people left farms and country life to seek new work in factory towns. Millions more left Europe for North America and other parts of the world.

THE LAST OF ENGLAND (detail) Ford Madox Brown, 1860
An immigrant family, setting sail for America, takes a last look at their homeland.

Childhood in the 1800's

Wealthy and middle class children led sheltered lives. They were educated at home by governesses or went to private schools. Poor children led very different lives. Their families needed the meager income they could earn and often put them to work by the age of five. Many children worked up to 16 hours a day in factories or as household servants, and received no formal education at all.

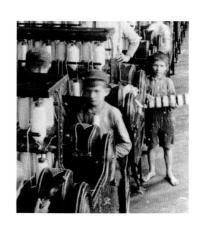

War and revolution

Wars bring tragedy, loss and upheaval to all who live through them. Soldiers die and watch their comrades die. Those at home face economic hardship and the loss of loved ones. The Impressionists lived through a succession of wars and revolutions. In 1848, when most of them were children, revolutions broke out across Europe — in France, Austria, Hungary, Switzerland, Ireland,

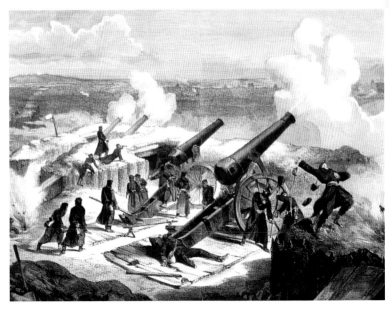

BOMBARDMENT OF PARIS, German print, c. 1870
Prussian soldiers fire canons at the French on the outskirts of Paris.

Denmark and several German and Italian states. Mary Cassatt lived through the American Civil War before moving to Paris to paint. A few years later, war broke out between France and Prussia, drastically affecting the lives of all the Impressionists. Some fought in the war; others left the country to escape the fighting. A few months after the Franco-Prussian War ended in French defeat, civil war broke out in Paris as thousands of citizens took up arms against the French government. In their old age, Monet, Renoir, Degas and Cassatt lived through yet another war, World War I.

Scientific exploration

The 1800's brought major advances in science. For example, Louis Pasteur discovered that bacteria spread many diseases. Because of his work, doctors began to sterilize equipment before surgery and childbirth, saving millions of lives. Charles Darwin published his theory of evolution. Gregor Mendel experimented with garden peas and discovered how traits are passed from parent to child, founding the science of genetics. Sigmund Freud explored the unconscious mind, pioneering the new field of psychology. At the turn of the century, Albert Einstein triggered a scientific revolution with his theories about space, time and how the universe works.

COMPOSERS of the 1800's

Frédéric Chopin
Franz Liszt
Richard Wagner
Johannes Brahms
Pyotr Tchaikovsky
Antonin Dvorák
Gustav Mahler
Claude Debussy

WRITERS of the 1800's

Victor Hugo
Alexandre Dumas
George Sand
Charles Dickens
The Brontë Sisters
Gustave Flaubert
Leo Tolstoy
Mark Twain
Emile Zola
Guy de Maupassant

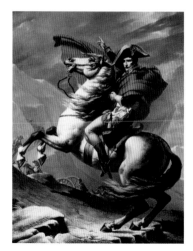

BONAPARTE CROSSING THE ALPS
Jacques-Louis David, 1801

Napoleon is shown as a heroic general on a stallion, leading his troops over the Alps into battle. In reality, when his army crossed the mountains, Napoleon was towards the rear, riding on a mule!

An artist whose painting is badly placed at the Salon offers visitors a view through his telescope for a small fee — which he pays to them!

In this cartoon, soldiers are using Impressionist art to scare the enemy.

How Impressionist paintings were different

This painting of Napoleon crossing the Alps represents an art style that was popular in the early 1800's, shortly before Impressionism. It grandly portrays a scene from history, depicting Napoleon as an ideal hero, not as he really was. Impressionist paintings were very different. Most were landscapes or simple scenes from everyday life, instead of momentous scenes from history, myth or religion.

Unlike previous artists, the Impressionists did not paint every little detail. Instead, they wanted to capture spontaneous moments and fleeting reflections of light on people and things. In earlier art styles, a painter's brush strokes were hardly visible and the surface of a painting was quite smooth. The Impressionists let their brush strokes show and sometimes put thick dabs of paint on the canvas. They also used brighter, more vibrant colors than earlier artists did. Impressionist paintings were so new and different that the public was shocked at first.

Rebellion against the official Salon

In the mid-1800's, when the Impressionists were just starting out, there was only one way for artists to achieve success. Their paintings had to appear in the national art exhibition, called the Salon, which was held in Paris each year. To have a painting accepted by the Salon, an artist first had to submit it to a panel of judges. Year after year, the Salon judges refused almost every Impressionist painting. The few that were accepted were usually displayed up high or in a place where they were easily overlooked.

Finally, in 1874, a group of Impressionist artists decided to put on their own exhibition. Unfortunately, only 3,500 people came to the month-long show, compared to 450,000 people who attended the official Salon. And most of those who came just jeered and made fun of the art. One reviewer said, "These artists appear to have declared war on beauty." But the Impressionists did not give up. They went on to hold seven more exhibitions over the next twelve years. Each time their paintings gained a little more acceptance.

Café chats

Monet, Renoir, Degas and Manet would paint all day, then get together at their favorite Paris café with other artists and writers. Monet recalled, "Nothing could be more interesting than these sessions with their perpetual clash of opinions. They kept our wits sharpened and provided us with stores of enthusiasm."

Painting outdoors

Before the Impressionists, artists sketched outdoors then returned to their studios to create the final painting. The Impressionists wanted to paint entire pictures outdoors. The recent invention of metal paint tubes and portable easels made it possible for them to work wherever they liked, but painting outdoors presented new challenges. In a studio, the light is fairly even, but outdoors it changes from one minute to the next. Each artist developed ways to capture the moment with a sense of spontaneity.

Japanese influence

After Japan began trading with the West in 1868, Japanese art and objects became hugely popular in France and had a major impact on the Impressionist artists. They particularly liked the simple line drawing, the flat areas of bold color, and the way the main subject was often off center. Many Japanese prints had no single point of focus so the eye of the viewer was encouraged to wander all over the picture. The Impressionists used some of these same devices.

Influence of photography

First invented in 1839, photography immediately became popular. By the 1850's artists, scientists and amateurs were taking pictures. In the late 1880's the first small box camera was invented, allowing almost anyone to take snapshots. Travelers returned with photographs from faraway places and people took pictures at home. In snapshots, people and things were often cut off at the edge of the picture and anything that moved came out a bit blurry. The Impressionists created these same visual effects in their paintings.

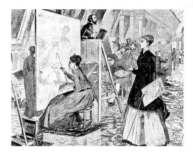

ART STUDENTS AND COPYISTS IN THE LOUVRE
Winslow Homer, 1867

In the 1800's, Paris was known as "the art capital of the world." Male students came to Paris to study at the prestigious School of Fine Arts. Women were not allowed to attend. Instead, they took private lessons and learned by copying paintings at the Louvre. Mary Cassatt once commented "Museums are all the teachers one needs."

ITSUKUSHIMA MOON
Tsukioka Yoshitoshi, 1886

MINDING THE BABY
Jacob August Riis, c. 1889

1830 The first public railway line in the world opens in England. A steam-powered train called *The Rocket* speeds along at 16 miles per hour carrying passengers between the industrial cities of Liverpool and Manchester.

1837 Queen Victoria is crowned. During her long reign, Great Britain establishes and maintains colonies around the world, prompting the saying "The sun never sets on the British Empire.'

1848 Revolutions erupt all over Europe. Many people are out of work and hungry. They fight to replace rich monarchies with more representative forms of government.

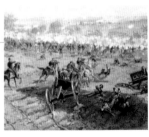

1861 Northerners fight Southerners in the American Civil War. During the war, President Abraham Lincoln begins to abolish slavery in America.

1860 Louis Pasteur, a French chemist, demonstrates the existence of bacteria and their role in the spread of disease.

1837 Samuel Morse invents the telegraph. For the first time, messages can be sent over long distances by wire, using Morse code.

1859 Charles Darwin publishes his theory that all animal and plant species develop gradually, by a process of natural selection and "survival of the fittest."

1868 Japan begins trading with the West for the first time in over 200 years. This brings Japanese art and products to the outside world.

1830 1840 1850 1860 1870

1839 Scottish blacksmith Kirkpatrick Macmillan invents the bicycle. Its frame is wooden and the pedals go up and down. His bike goes so fast that he is fined for "furious driving."

1853 Florence Nightingale organizes the first modern nursing service for British soldiers fighting in the Crimean War. During the war, more soldiers die of disease than in battle.

1870 The French fight the Germans in the Franco-Prussian War. Parts of Paris are set on fire.

1839 Louis Daguerre invents daguerreotype photography. People posing for a photograph must remain perfectly still for several minutes. That's why no one smiles!

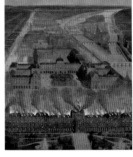

1840's Propeller-driven steamships begin to replace sailing ships for ocean crossings. They still have sails to use when the wind is good or if the engines fail.

1895 French brothers Louis and Auguste Lumière invent a movie camera and shoot the first motion picture ever made.

1895 Italian engineer Guglielmo Marconi invents the radio and a system for broadcasting sounds over long distances without wires.

1876 Scottish-born American Alexander Graham Bell invents the telephone. For the first time, the human voice can be transmitted by wire over long distances.

1920 Women win the right to vote in the United States, a victory for the women's suffrage movement that began over 70 years earlier.

1886 German engineer Karl Benz invents the automobile. It is the first "horseless carriage" to be powered with an internal-combustion engine.

1914 World War I breaks out. Ten million people are killed in the fighting. Shortly after the war, over 20 million die in a worldwide influenza epidemic.

1880 1890 1900 1910 1920

1875

1874 German composer Richard Wagner completes the *Ring of the Nibelungs*, both composing the music and writing the words to his series of four operas. At first, his radical new style of music shocks opera-goers.

1912 The Titanic, called "unsinkable" when it was launched, hits an iceberg on its maiden voyage across the Atlantic and sinks.

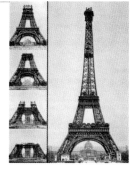

1889 The Eiffel Tower is built for the Paris Exhibition. Tall, metal-framed buildings and long suspension bridges are only recently possible due to Bessemer's discovery of a much cheaper way to make steel.

1905 Albert Einstein, at 26 years old, publishes his special theory of relativity. Over the next several decades, his work revolutionizes our understanding of the universe.

1878 British chemist Joseph Swan invents the electric light bulb. Electric lights begin to replace gas lamps and oil lanterns.

1903 The Wright brothers, Wilbur and Orville, build and fly the first airplane during time off from their bicycle business. Their first flights last less than a minute.

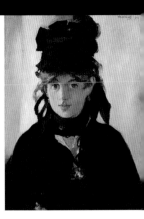

EDOUARD MANET **CAMILLE PISSARRO** **EDGAR DEGAS** **BERTHE MORISOT**

Edouard Manet 1832 – 1883

Edouard Manet wanted to be an artist but his father wanted him to be a lawyer. As a compromise, he went to sea at 16 as a cadet in the French Navy, but spent much of his time drawing. His father finally gave in and let him study art. For fun in class, he liked to draw things perfectly, but upside down. At 31, he married a young Dutch pianist, Suzanne Leenhoff. For 24 years, Manet shocked the public with his bold new style of art. He died at 51 of a chronic disease he had contracted as a young man.

Camille Pissarro 1830 – 1903

Camille Pissarro was born on the Caribbean island of Saint Thomas. His father was French and Jewish, his mother Creole. After a few years as a clerk in his father's textile business, Pissarro left for Venezuela to be an artist, then eventually settled in France. For years, he struggled to support his wife and eight children with his painting. Called "Papa Pissarro" by almost everyone, he was much loved by other artists, and his five sons grew up to be artists themselves.

Edgar Degas 1834 – 1917

Edgar Degas grew up in a family of wealthy Italian bankers who lived in Paris. After spending a few years in Italy, he returned to Paris where he befriended Edouard Manet while the two were copying paintings in the Louvre. Degas also became a superb print maker and photographer. When his eyesight failed after forty years of painting, he turned to sculpture, working by feel and by memory. Degas was a man of harsh words and strong prejudices, but in his old age he softened, asking forgiveness of friends he had offended.

Berthe Morisot 1841 – 1895

Berthe Morisot had a privileged upbringing. Her father, like Manet's, was a high ranking government official. The two artists met while painting at the Louvre and became good friends. Morisot eventually married Manet's younger brother. She exhibited her work in seven of the eight Impressionist exhibitions, missing only one for the birth of her daughter. Her sudden death from influenza at age 54 shocked and saddened the entire community of Impressionist artists.

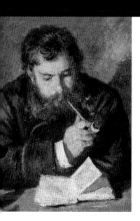
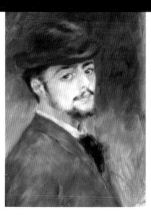
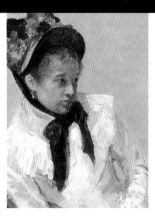

CLAUDE MONET **AUGUSTE RENOIR** **MARY CASSATT** **GUSTAVE CAILLEBOTTE**

Claude Monet 1840 – 1926

Claude Monet grew up in the seacoast city of Le Havre with a passion for art and the sea. He and Renoir were art students together in Paris where Monet soon became one of the leaders of the Impressionist art movement. Against his family's wishes, he married Camille Doncieux, one of his models. She died of cancer at age 32, shortly after giving birth to their second son. Monet and his second wife, Alice, raised their combined family of eight children in a style his country neighbors considered odd and "bohemian."

Auguste Renoir 1841 - 1919

Born into a poor family, Auguste Renoir took his first job at 13 as a porcelain painter's apprentice, earning small change for each plate and vase he decorated. At 20, he quit work to begin formal art studies, and soon struck up his life-long friendship with Monet. At 40, he fell in love with Aline Charigot, a 19-year-old seamstress and one of his models. Renoir became a wise and loving father to their three sons. In spite of crippling arthritis, he hardly let a day go by without painting.

Mary Cassatt 1844 – 1926

Born in Pennsylvania to a wealthy family, Mary Cassatt spent a few years in Europe as a child, then returned to France to study art over her father's initial objections. (He said he'd almost rather see her dead than an artist.) Cassatt painted prolifically even though she took much time off to care for her ailing sister and mother. In her seventies, she lost her eyesight and spent the last ten years of her life in frustration, unable to paint. Though she lived most of her life in France, Cassatt was always proud to be an American.

Gustave Caillebotte 1848 - 1894

Gustave Caillebotte, heir to a textile fortune, earned a law degree before turning to art. He liked to paint scenes of modern urban life, using unusual perspectives that heightened their sense of drama. In spite of his great wealth, Caillebotte never put on airs. In fact, he was quite modest, putting others' concerns before his own. He never married. One day, at age 45, he suddenly took sick and died a few weeks later of something the doctors called "brain paralysis," a kind of stroke.

9

*E*douard Manet painted flowers for their beauty, but he also gave this painting symbolic meaning. In a simple vase of flowers, Manet depicted the cycle of life, from birth to death. He painted flowers as young buds, in full bloom, drooping, and dead. The flowers at the top of the painting are at the peak of their strength and beauty. They are red, the color of passion and life at its fullest. At the bottom of the painting lie the wilted petals of a dead flower. They are next to a fresh bloom whose stem curves up towards the living flowers. From death back to life, the cycle continues.

A new style of painting

Artists before the Impressionists painted flowers with lots of detail. In Dutch artist Ambrosius Bosschaert's painting you can see every vein in the leaves and petals. Manet preferred to capture the beauty of flowers without copying them exactly.

Reluctant revolutionary

Manet's bold new style inspired the younger Impressionists. He was one of their leaders, yet he never wanted to be an art revolutionary. He was so determined to be accepted by the traditional art establishment (known as the Academy) that he refused to show his work in any of the Impressionist exhibitions. Manet gained fame as an artist but it was not the kind he wanted. For many years, his paintings were ridiculed and despised by critics and by the public.

PEONIES IN A VASE, 1864, oil on canvas,
37" x 31" (93 x 79 CM), Musée d'Orsay, Paris, France.

Edouard

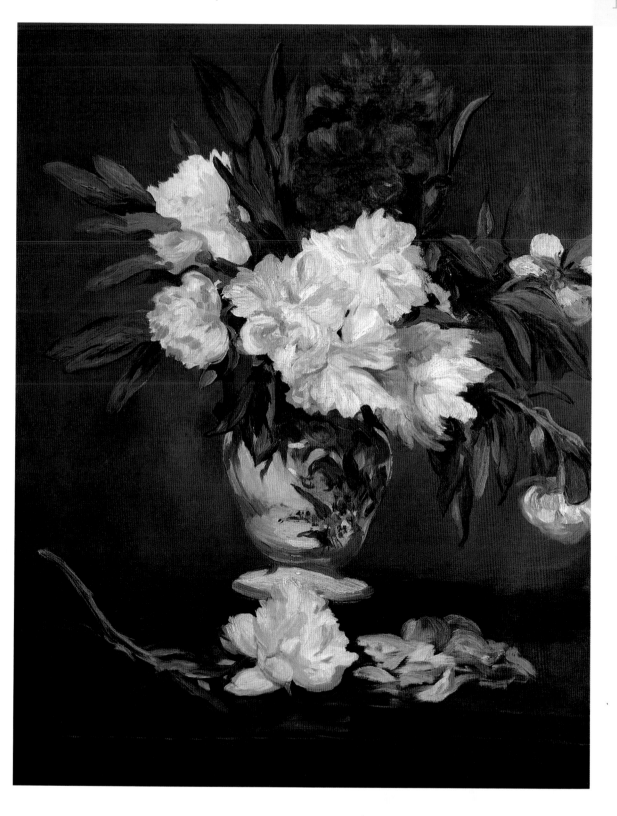

*T*he models for this painting were friends of Manet who posed for many long hours in fifteen separate sessions. The artist was so taken with Berthe Morisot (seated at the railing) that he painted her with much more intensity and detail than he did the others.

"It's perfect."

Manet's friends got so tired of posing that they decided to tell him the painting was perfect so he would stop working on it. In truth, they felt it was going nowhere. Poor Fanny (a talented young violinist) looked silly with a huge white flower on her head, and Antoine (an artist) looked stiff and bored, which he certainly was! Only Berthe brought the painting to life. While posing, she was also studying Manet's art techniques.

"Trick the eye"

Manet painted the balcony railing to look real. This is called a *trompe l'oeil*, which means "trick the eye" in French. If the artist can make us believe the railing is real, and not just painted, he might trick us into feeling as if we were in the same space with the people in the painting.

THE BALCONY, 1868-9, oil on canvas,
67" x 49" (169 x 125 CM), Musée d'Orsay, Paris, France.

High contrast

Before Manet, artists usually painted faces with many subtle tones of color. This made them look more three-dimensional. In Manet's paintings you'll notice more contrast and a flatter look. He painted darker darks and lighter lights and skipped the middle tones. And he did not mind letting you see his brushwork.

GRAND ODALISQUE
Jean-Auguste Ingres, 1814

In a figure, look for the highest light and the deepest shadow, the rest will come naturally.

— *Manet's advice on painting a portrait*

Edouard

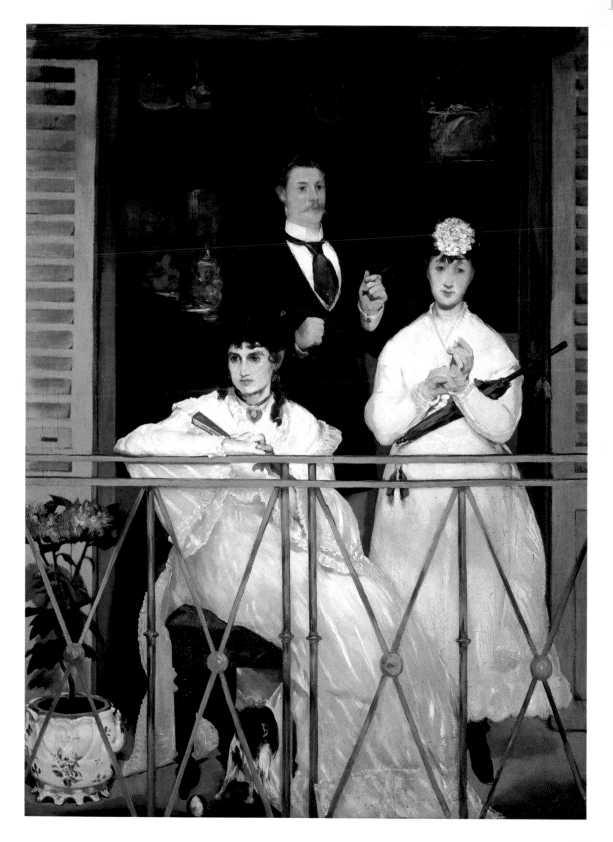

*A*little girl looks down at trains pulling in and out of the St. Lazare station in Paris. She is with her mother or governess. All we can see of the train station are the tracks and the steam rising from a locomotive.

Genre paintings: slices of everyday life

Paintings of ordinary people going about their daily lives are called "genre paintings." For centuries, these paintings were considered less important than ones with religious, mythological or historical subjects. The Impressionists loved depicting everyday scenes: friends having lunch, someone bathing, peasants in a field. They helped elevate such simple subjects to a new level of importance in art.

Essence of puppy

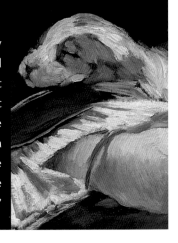

You can almost feel this puppy lying in your arms. Manet captured the essence of the puppy with just a few brushstrokes. Berthe Morisot once said, "Only Manet and the Japanese are able to indicate a mouth, eyes or nose in a single stroke, but so concisely that the rest of the face takes on modeling."

Edouard

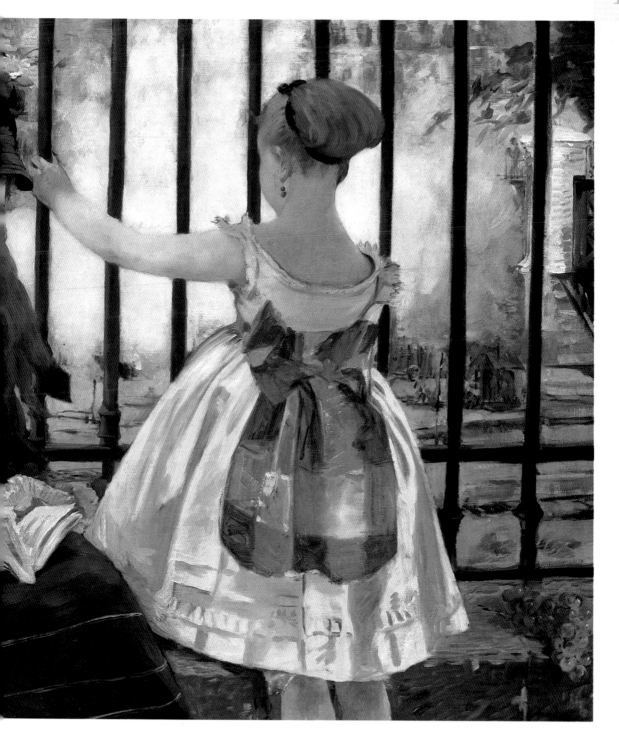

Painting begins with Manet.

— Paul Gauguin, *Post-Impressionist artist*

AT THE RAILWAY STATION, 1873, oil on canvas, 37" x 45"
(93 x 112 CM), National Gallery, Washington, D.C., U.S.A.

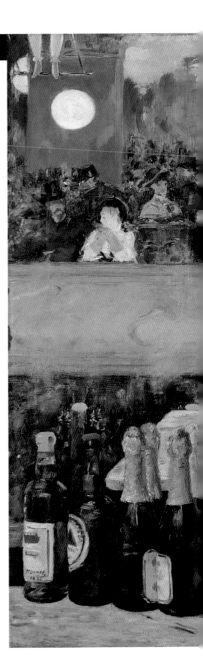

*I*n the 1880's, the Folies-Bergère was considered one of the most exciting music halls in Europe. Men came alone or brought their lady friends to enjoy an evening of lively entertainment.

What's "wrong" with this picture?

How many ways can you find that Manet's painting is "unreal"? Here are three: 1. The barmaid's reflection in the mirror is not where it would be in real life. 2. Her customer appears only in the mirror, and he is huge. Imagine how tall he would be if he were standing in front of the bar. 3. The fruit and bottles on the bar sparkle with daylight reflections, even though this is a night scene.

Manet first painted an accurate reflection of the barmaid, then he changed his mind and repainted it this way. He painted the bar and everything on it in his studio, in the light of day.

Manet's goodbye

When he painted this, Manet knew he was dying. On the bar, he painted bottles of champagne, fresh flowers and a bowl of fruit — all symbols of life and gaiety. In the mirror behind the barmaid, he painted a large crowd laughing and talking as a trapeze artist performs overhead. Yet, in the midst of all this fun and entertainment, the barmaid appears sad and distracted. The painting is Manet's melancholy farewell to the Paris nightlife he loved so much.

Edouard

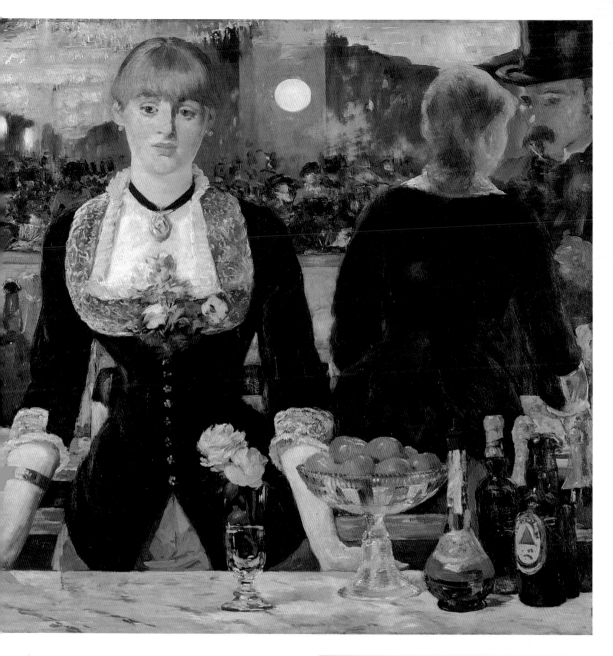

Elegant man about town

While his friends went to the country to paint, Manet preferred to remain in the city. Each afternoon, he would stroll along the boulevards of Paris, impeccably dressed, wearing a silk top hat and carrying a fancy walking stick — not what people expected of a rebel artist!

A BAR AT THE FOLIES-BERGÈRE, 1882, oil on canvas, 38" x 51" (96 x 130 CM), Courtauld Institute Galleries, London, England.

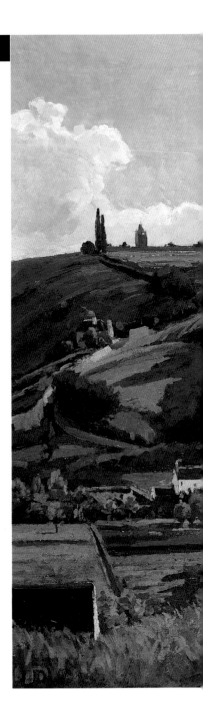

*P*issarro preferred country life to living in the city. He strapped an easel and a box of paints on his back and set off on painting excursions, either alone or with artist friends. This scene was painted near his home in Pontoise, a village on the Oise River not far from Paris.

Paintings without a story

According to Pissarro there are two kinds of paintings. "Literary paintings" tell a story taken from history, religion, or mythology. "Painter's paintings," such as a landscape or a scene from everyday life, are to be seen and experienced just for themselves. These are what Pissarro and the other Impressionists liked to paint.

Teacher and student of great artists

Pissarro was a mentor and father figure to many young artists, some of whom became more famous than he. He helped Paul Cézanne, Vincent Van Gogh and Paul Gauguin, who later became known as the great Post-Impressionist artists. Cézanne recalled, "Pissarro was like a father to me." Unlike other established artists, Pissarro liked to learn from young artists. He experimented with the different art techniques they were developing.

Paint what you feel

Pissarro advised young artists, "Don't proceed according to rules, but paint what you observe and feel. Paint generously and unhesitatingly, for it is best not to lose the first impression."

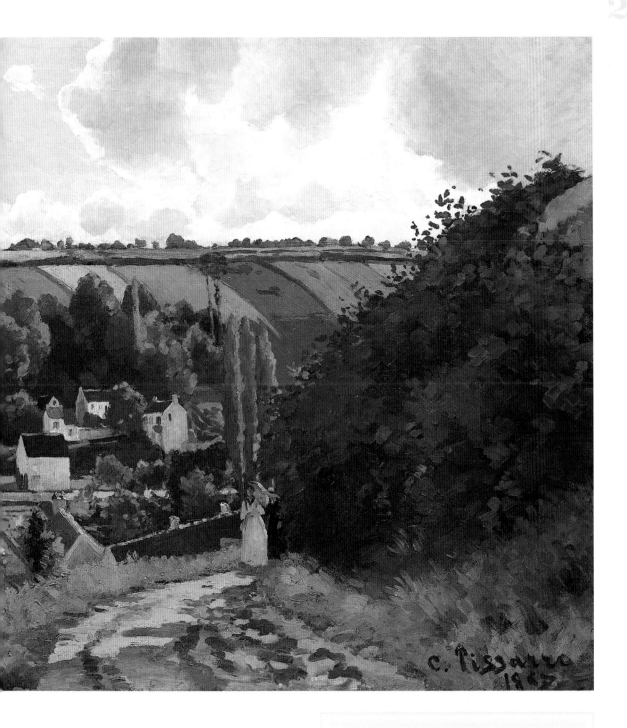

THE JALLAIS HILLS, PONTOISE, 1867, oil on canvas, 34" x 45" (87 x 115 СМ), Metropolitan Museum, New York, U.S.A.

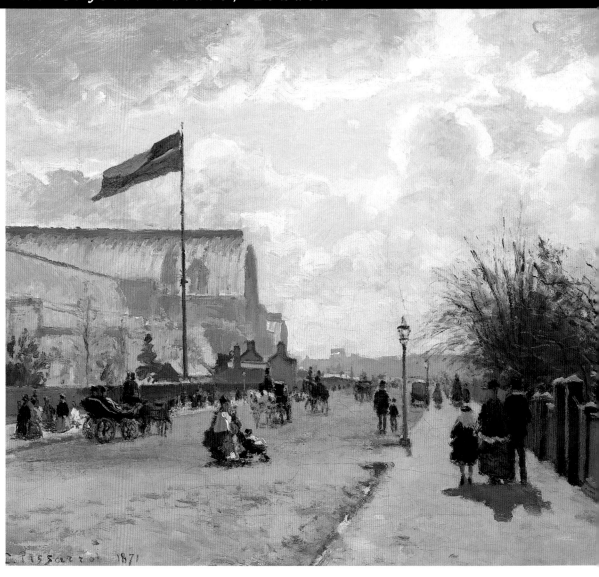

THE CRYSTAL PALACE, LONDON, 1871, oil on canvas, 19" x 29"
(47 x 74 CM), Art Institute of Chicago, U.S.A.

The Crystal Palace was about 1,800 feet long (the length of six football fields!) with more than 900,000 square feet of glass. This illustration shows part of its vast interior hall. In 1854, it was dismantled and moved from London's Hyde Park to the nearby town of Sydenham, where Pissarro painted it.

he Crystal Palace was built to house the Great Exhibition of 1851, a world's fair held in London. The exhibition was organized by Prince Albert, Queen Victoria's husband, who wanted to put Great Britain's many industrial achievements on display. The Crystal Palace itself was a marvel of new technology. Designed and built in less than nine months, it was the largest building the Victorian world had ever seen.

Art and lives destroyed by war

Pissarro painted this while living in England during the Franco-Prussian War, fought between France and what is now Germany. For several months, Paris was under siege and surrounded by enemy troops. Many Parisians were reduced to eating cats, dogs, and even rats to keep from starving. While Renoir, Manet and others fought in the war, both Pissarro and Monet fled to England to escape the fighting. During the war, Pissarro's house in France was commandeered by the Prussian army and used as a stable. Almost all of his paintings — over a thousand works of art — were lost or destroyed.

Marrying below one's station

Pissarro fell in love with a kitchen maid who worked for his family. Because they came from different social classes, Pissarro's family disapproved of the match and forbade them to marry. They lived together anyway and had two children before finally getting married in England during the war. There, they were far away from his disapproving family.

*I*t is spring. A group of young women are planting tall sticks in a field near their village to support the climbing peas that will grow there during the summer.

Escapist art

Many Impressionist paintings depict the beauty and tranquility of country life. But in reality, the Impressionists lived during a time of great upheaval and change. During the 1800's, millions of people left their farms to move to cities in search of jobs created by the Industrial Revolution. Railroads and factories sprouted up where before there was open countryside. Paintings of idyllic country scenes like this offered an escape from all the rapid changes industrialization was bringing.

Fan paintings

This is one of over thirty fans that Pissarro painted. Decorative fans became popular in the late 1800's, an influence of Japanese art. Degas, Morisot and Pissarro all painted them. But unlike Japanese painted fans, these were never meant to be used; they were framed and hung on the wall like other paintings.

Paint the essential character of things, try to convey it by any means whatsoever, without bothering about technique.

— *Camille Pissarro, advice to a young painter*

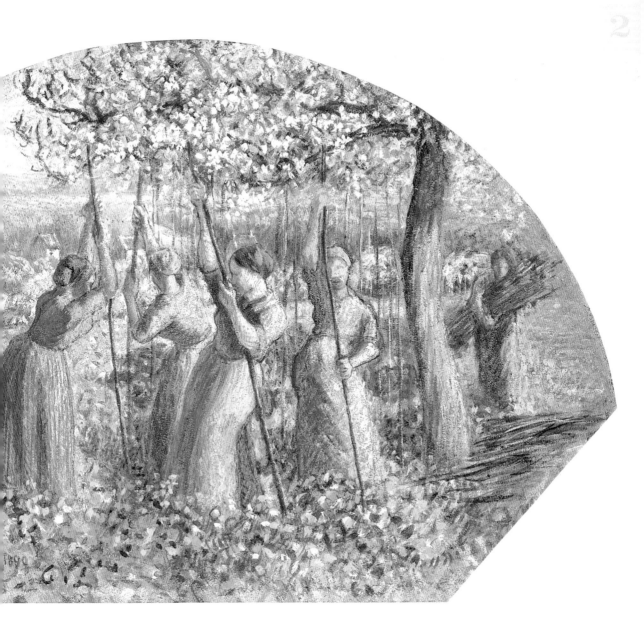

Gouache is watercolor paint to which white pigment has been added, making the paint opaque instead of transparent. Although gouache is used in much the same way as regular watercolors, the feel of a gouache painting is much more solid.

PEASANTS PLANTING PEA STICKS, 1890, gouache & chalk on paper, 15" x 24" (39 x 60 CM), Ashmolean Museum, Oxford, England.

GOUACHE REGULAR WATERCOLOR

*P*issarro captures life in Paris at the turn of the century. This busy boulevard in the Montmartre district is lined by wide new sidewalks. Gas street lamps, a recent invention, light the way for horse-drawn carriages. Shoppers hurry past brightly lit shop windows.

Modern Paris

In 1853, Emperor Napoleon III and Baron Georges Haussmann set out to redesign the city of Paris. Shabby old buildings were torn down and replaced with 40,000 new buildings, including grand hotels, theaters, apartment buildings and department stores (a new invention).

Narrow, winding streets were replaced by 85 miles of wide tree-lined boulevards graced with gas street lamps, sidewalks, and even public toilets.

The redesign of Paris was not just to make the city more beautiful. Not long before, the citizens of Paris had revolted against the government, barricading many streets and shooting at the government soldiers. Napoleon III knew that wide boulevards would be much harder to barricade. Also, with wider streets, the army would be able to move quickly throughout the city.

Painting a rainy night

To make the sidewalks look wet, Pissarro painted them with reflections of trees and storefronts. Everything is blurry, as it would look to us on a rainy night. The street lamp closest to us has a halo around it, an effect created by moisture in the air. All of this produces the effect of a rainy night in the city.

I am delighted to paint those Paris streets that people have come to call ugly, but which are so silvery, so luminous and vital...
This is completely modern!

— *Camille Pissarro*

Camille

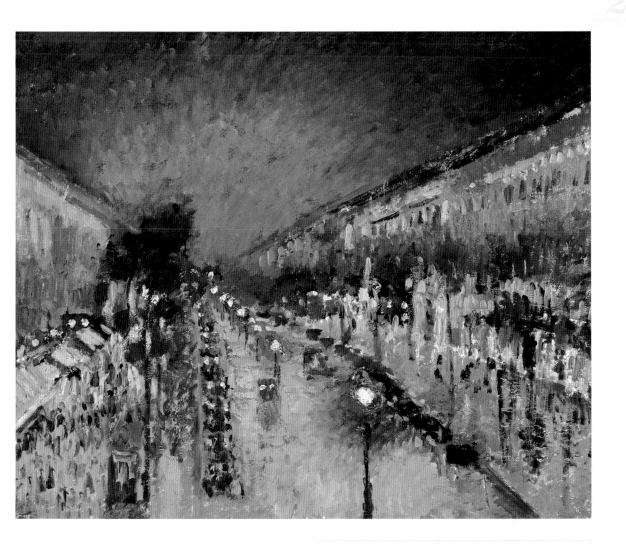

BOULEVARD MONTMARTRE AT NIGHT, 1897, oil on canvas, 21" x 26" (54 x 65 CM), National Gallery, London, England.

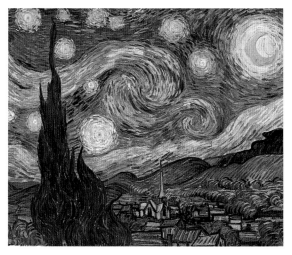

THE STARRY NIGHT Vincent Van Gogh, 1889

Van Gogh and Pissarro

The skies in Pissarro's other paintings look more like real skies, while this one consists of a fan of separate brush strokes. Perhaps Pissarro was influenced by his friend, Van Gogh, who loved to paint swirling night skies.

*M*ost Impressionists took their easels outdoors to paint directly from nature, but not Degas. For this painting, he made sketches of horses and racetracks, then returned to his studio to paint. He said, "You reproduce only what has struck you, what is essential; in that way your memories and your imagination are liberated from the tyranny that nature holds over them."

How horses move

Degas spent hours studying horses, as well as photographs of them, in order to paint with accuracy. Before the invention of photography, artists could not easily see how horses galloped. They sometimes depicted them with all four legs stretched out and off the ground. Action photographs like the series below showed how horses *really* galloped.

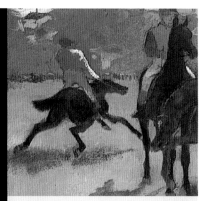

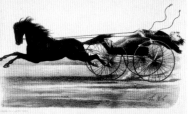

BOLTED!

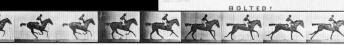

Can you see the differences between these two kinds of oil paint? Regular oil paint (left) is shiny and thick. Essence (right) is matte and thin. It is made by putting paint on a blotter to absorb most of the oil, then adding turpentine.

Edgar

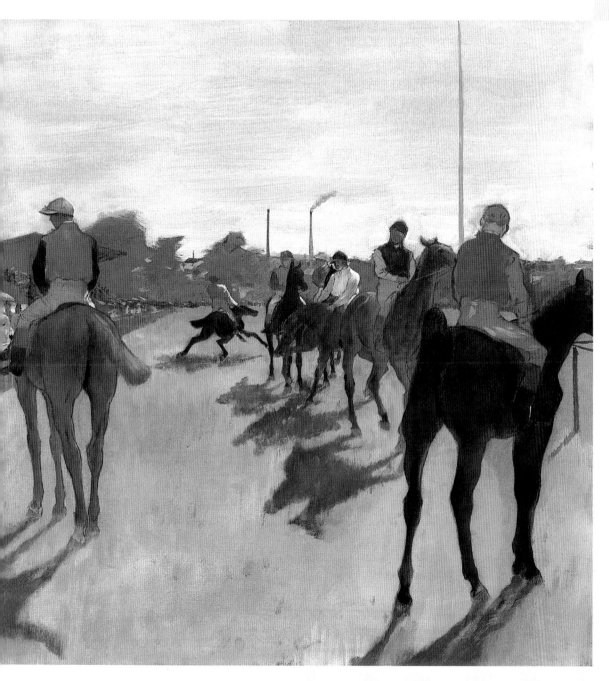

Letting your "underwear" show

Artists usually began a painting by covering a canvas with an undercoat of paint. Degas lets his undercoat show through. (Can you see the brown in the sky?) Traditional artists thought this was improper — like letting your underwear show.

RACEHORSES BEFORE THE STANDS, 1866-68, essence on paper, 18" x 24" (46 x 61 CM), Musée d'Orsay, Paris, France.

*D*egas was fascinated by the performers of the Fernando Circus. Here he captures Miss La La, a young black acrobat, as she is being pulled high above the audience by a rope grasped only with her teeth. In her most daring feat, Miss La La held a small cannon by a chain in her teeth while hanging upside down from a flying trapeze. The cannon was then fired!

Painting danger

The walls and ceiling of the circus building were not really bright orange. Degas created the red and orange glow to convey the danger and excitement of Miss La La's performance.

Body language

Degas was not that interested in people's faces. Many of his paintings show people with their faces turned away, blurry, or even left blank. What he really cared about was body language. He wanted to capture how people moved and what emotions they expressed with their bodies.

Artist's tip

When artists want to paint from a sketch, they begin by dividing the sketch and the canvas into a grid of squares, then copy the drawing one square at a time. Try this yourself, if you'd like to make a drawing from a photograph or favorite picture.

MISS LA LA AT THE CIRQUE FERNANDO, 1879, oil on canvas, 46" x 31" (117 x 78 CM), National Gallery, London, England.

A painting requires a little mystery, some vagueness, some fantasy. When you always make your meaning perfectly plain you end up boring people.

— Edgar Degas

Edgar

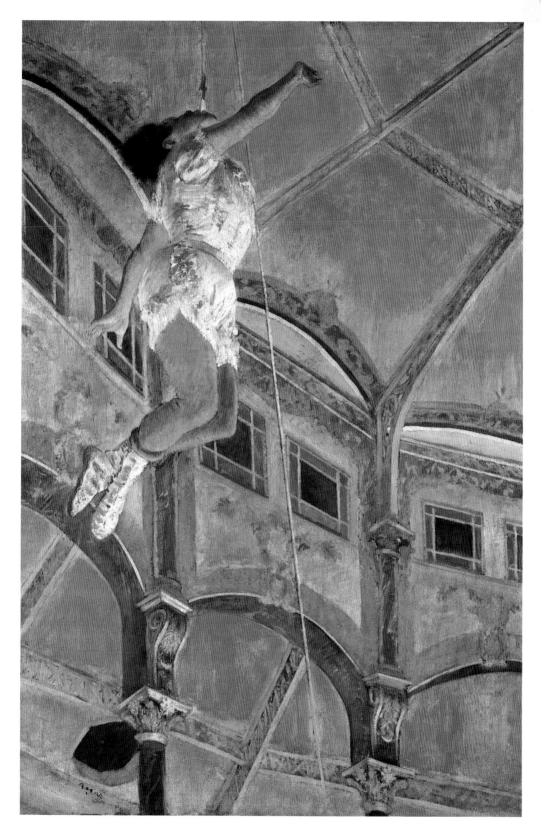

egas is most famous for his hundreds of ballet paintings. This ballerina bends forward, balancing on one foot. By painting a ballet position that lasts ever so briefly, Degas captures the lively tension of the moment and creates an energetic piece of art.

Dancing out of poverty

Dancers in Degas' day almost always came from poor families. Most grew up in one-room apartments in the slums of Paris. The mother of an aspiring ballerina might be a seamstress or washerwoman hoping to give her daughter a better life. If a young girl were lucky, she would be accepted into the Académie Royale, the opera's dance school, at the age of eight, and make her stage debut by the time she was fifteen.

Artificial light

Degas loved the dramatic effects created by artificial light, which often shines up at people, not down upon them as natural light always does. Here, the ballerinas are brightly lit by the footlights on stage.

> **GREEN DANCER**, 1880, pastel & gouache on paper, 26" x 14" (66 x 36 CM), Thyssen-Bornemisza Collection, Madrid, Spain.

The powder of butterfly wings

Pastels come in sticks, like chalk, but are softer. They are made by mixing pigments of different colors with chalk or clay. As he grew older, Degas preferred pastels to oil paints. He was beginning to lose his eyesight, and painting with oils required more precision and sharper eyesight than drawing with pastels. Also, he could work faster with pastels, switching quickly from one color to another without waiting for paint to dry. Above all, Degas loved the effects he could create with pastels, which were once likened to the "powder of a butterfly's wings."

Shimmering colors

The orange and blue-green colors in the dancers' dresses are "complementary" meaning they are opposite one another on the color wheel. When they are side by side, each color makes the other seem more vibrant. The orange flecks shimmer against the blue-green.

These pastel sticks are like the ones Degas used in *Green Dancer*.

Edgar

It is the
movement
of people
and things
that distracts
and even
consoles me.
If the leaves
of the trees
did not move,
how sad
the trees
would be
and we, too.

— Edgar Degas

Look how vibrant this shade
of orange is when it is next to
its complementary color of
blue-green. The same orange
appears less brilliant next to a
color that is closer to it on the
color wheel. The farther apart
two colors are on the color
wheel, the more vibrant they
appear when seen side by
side. (See color wheel on
page 47.)

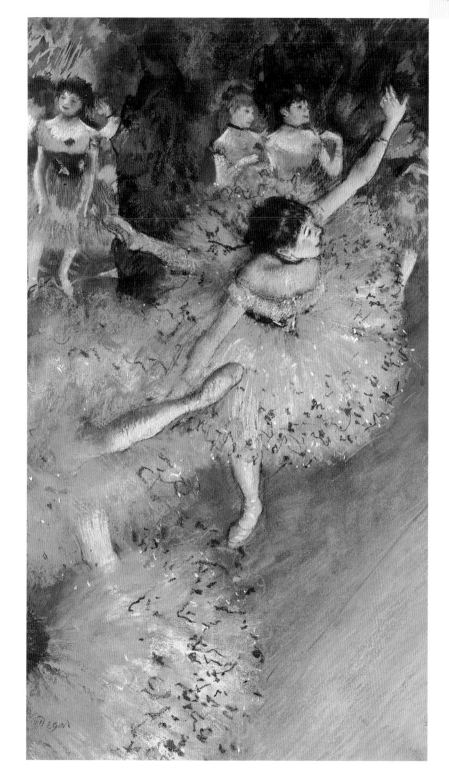

Before the Impressionists, nudes were usually painted as gods or goddesses. They were posed in ways that invited viewers to admire their physical beauty. Degas' paintings were quite different. He wanted to capture women in their private daily routines, seemingly unaware of anyone watching them.

Cut off at the edges

Degas cut off the water pitcher and toiletries lying on the table as if he were taking a photograph. The Impressionists were the first artists to be influenced by photography, which was a recent invention. They were also influenced by Japanese art, which often had cut-off objects at the edges. The cropped toiletries give us the impression that we are standing close to the table and to the bather. It also gives the picture the spontaneity of a snapshot.

Never finished

Degas could hardly bear to part with his works of art. After selling them, he would borrow them back to rework them, occasionally ruining them with his repainting. Knowing this, one buyer (a friend of Degas) refused to let him borrow back a ballerina painting. The story was told that he padlocked it to his wall to keep Degas from taking it, but the man's son insisted this wasn't really true.

Edgar

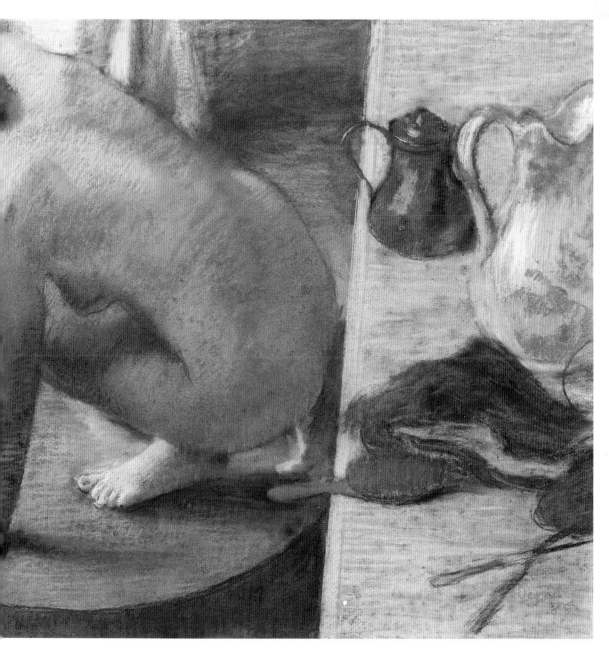

Bathing in the 1800's

Most homes in the 1800's did not have bath-
rooms with hot and cold running water. That was
still a rare luxury. Some people bathed in small
tubs, using pitchers of water that had been
heated on the stove. Others took sponge baths.

WOMAN BATHING IN A SHALLOW TUB, 1886, pastel on paper,
24" x 33" (60 x 83 CM), Musée d'Orsay, Paris, France.

*M*orisot's mother reads while her sister, Edma, sits lost in thought. Edma is awaiting the birth of her first child. Following the custom of the day, she is staying with her mother for the last few months of her pregnancy, a time when women of her class were expected to remain quietly at home and not do much of anything.

Too much help

Morisot wanted to submit this painting to the panel of judges who selected art for the Salon, the prestigious national art exhibition. She asked Edouard Manet to come look at it first and give her his advice.

"He took the brushes," she recalled, "and put in a few accents. Once he had started nothing could stop him; from the skirt he went to the bodice, from the bodice to the head, from the head to the background. He cracked a thousand jokes, laughed like a madman, handed me the palette, then took it back."

Four hours later, he finally stopped. Morisot was devastated by what he had done. After long months of work, the painting was no longer completely hers — and at first she disliked Manet's changes, calling the retouched painting "a pretty caricature." After days of anguish, she decided to submit it to the Salon anyway, to avoid offending Manet. It won a place in the exhibition.

Proper reading for women

In the 1800's there was much debate about what women should be allowed to read. In some strict households, they were limited to the Bible and books of moral instruction. Even in many liberal homes, novels were considered too frivolous. Some novels were even thought to be dangerous!

Berthe Morisot had a special magnetism, bringing out the genuine in others. She had a gift for smoothing rough edges. Even Degas was more civil when he was with her.

— Jean Renoir, Auguste Renoir's son

MOTHER AND SISTER OF THE ARTIST, 1869-70, oil on canvas, 40" x 32" (101 x 82 CM), National Gallery, Washington, D.C., U.S.A.

Berthe *Morisot*

*M*orisot's most famous painting shows her sister, Edma, watching her baby daughter as she sleeps. Edma remained at her parents' home for several months, regaining her health and strength after the birth of her second child.

Dangerous talent

In the 1800's, refined young ladies were expected to dabble at art and music, but they were not supposed to become professional artists or musicians. When Berthe Morisot was sixteen, her mother wanted her and her sister, Edma, to take art lessons. Their teacher was soon astonished by their talent and worried that serious art lessons might change their lives. He told their mother, "My teaching will not endow your daughters with minor drawing room accomplishments; they will become painters. Do you realize what this means? In the upper-class milieu to which you belong, this will be revolutionary; I might almost say catastrophic. Are you sure you will not come to curse the day when art became the sole arbiter of the fate of two of your children?"

THE CRADLE, 1872, oil on canvas, 22" x 18" (56 x 46 CM), Musée d'Orsay, Paris, France.

Behind a veil
Morisot gives us the impression the baby is behind a veil of sheer netting by painting her face without any sharp lines or strong colors.

Artist, wife and mother

Women artists were expected to give up painting when they married. It was thought a woman could not combine an artist's career with the responsibilities of a wife and mother. Berthe's sister quit painting when she married, and Mary Cassatt chose to remain single, but Berthe managed to do it all. At 34, she married Edouard Manet's younger brother, Eugène, who understood his wife's passionate need to paint. He helped her with the sale of her paintings and gave her the freedom she needed to work.

Berthe *Morisot*

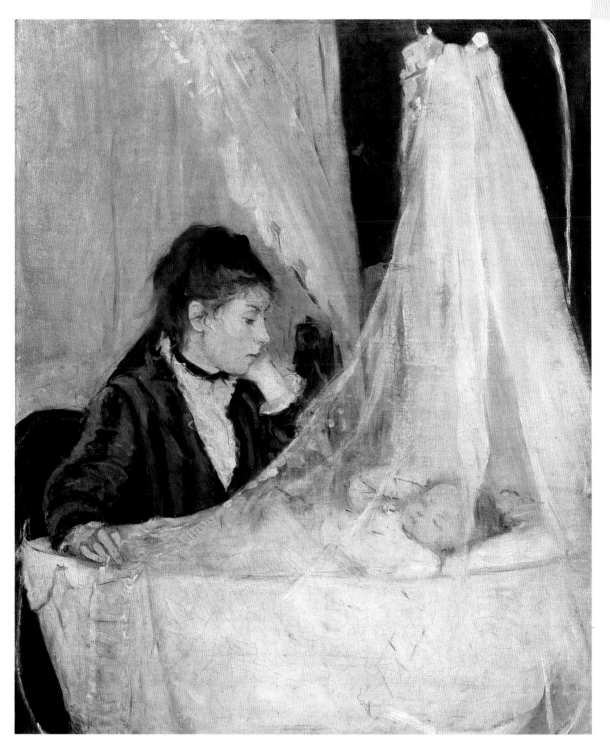

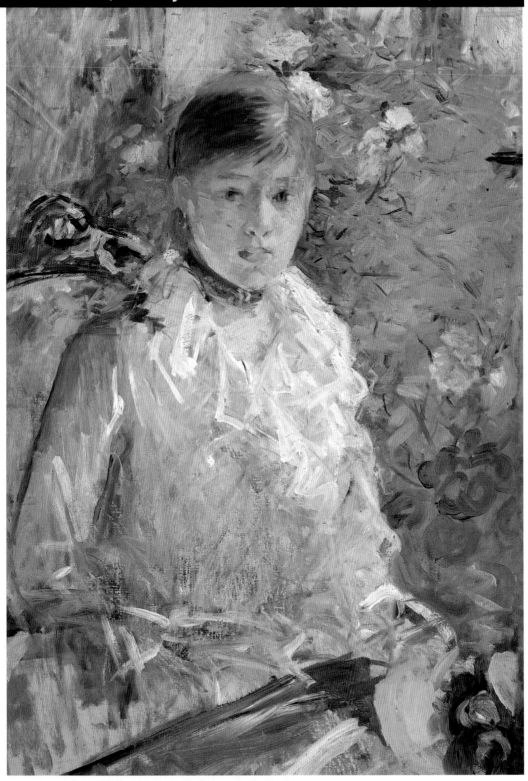

This is one of a pair of paintings Morisot did, called *Summer* and *Winter*. The radiant young woman with flowers at her window is meant to represent the summer season. This is called an allegorical painting because the person we see is symbolic of something else.

Freedom to paint

Men were free to paint whatever they wished: street scenes, dance halls, circuses, race tracks. But Cassatt and Morisot, as women of the upper class, could not wander about Paris by themselves, painting anything they chose. They were almost always chaperoned.

Marie Bashkirtseff, an artist of the same period, once wrote, "I long for the freedom to go about alone…stopping and looking at the artistic shops, entering churches and museums, walking about the old streets at night…that's the freedom without which one cannot become a real artist."

Of course Morisot and Cassatt became extraordinary artists in spite of their many restrictions. Both women focused on the subjects that were most available to them: women and children.

Reflections of light

Morisot has been called "the quintessential Impressionist artist." She focused on depicting the light *reflected* from objects rather than the objects themselves. She captured the look and feel of this sheer white blouse by painting only the highlights.

SUMMER (YOUNG WOMAN AT A WINDOW), 1878, oil on canvas, 30" x 24" (76 x 61 CM), Musée Fabre, Montpellier, France.

She grinds flower petals onto her palette so as to spread them on her canvas with airy, witty touches, thrown down almost haphazardly.

— *Charles Ephrussi, art critic*

Berthe Morisot

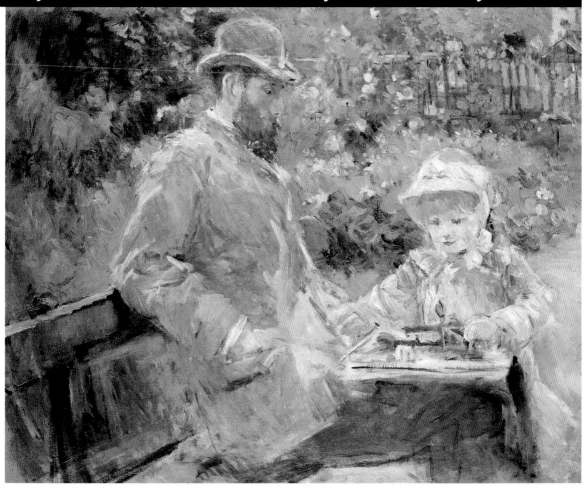

EUGÈNE MANET AND HIS DAUGHTER AT BOUGIVAL, 1881,
oil on canvas, 29" x 36" (73 x 92 CM), Musée Marmottan, Paris, France.

Berthe

erthe Morisot's husband looks on as their daughter, Julie, plays with a toy village in the garden of their summer home. Practically the only men to appear in Cassatt's and Morisot's paintings are family members. It was considered improper for a woman to ask a man to pose for her — even if he were a fellow artist for whom she had posed.

Unfinished painting?

Art reviewers often criticized Morisot's paintings as slapdash or unfinished-looking. One critic commented, "It's a real pity to see the artist give up her work when it is only barely sketched." Another wrote, "With this talent, why doesn't she take the trouble to finish?" But Morisot painted this way on purpose. She wanted to capture a fresh and spontaneous moment with her free-wheeling brushstrokes.

Painter without a profession

Even though Morisot painted and exhibited her work for over twenty-five years, many people dismissed her as an amateur because she was a woman. Her death certificate notes that she was "without any profession."

Good friends

Berthe Morisot and Auguste Renoir were born just a few months apart, but they grew up in very different circumstances. Morisot's family was wealthy. She grew up surrounded by servants and was educated by an English governess. Auguste Renoir, the son of tailor and a dressmaker, had a very simple upbringing.

Despite their different backgrounds, the two artists had much in common and became close friends. After her husband died, Morisot asked Renoir to be a guardian of her daughter in the event anything happened to her while Julie was still young. Tragically, Julie was orphaned at sixteen. Morisot and her daughter both fell ill during an influenza epidemic. Julie survived but her mother died. In the years to follow, Renoir often helped Julie with her painting.

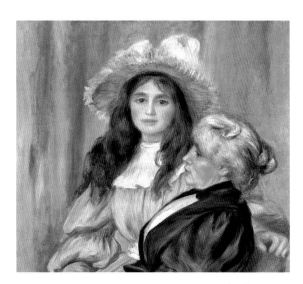

BERTHE MORISOT AND HER DAUGHTER, JULIE (detail)
Auguste Renoir, 1894

Renoir painted this portrait of Berthe Morisot and her fifteen-year-old daughter, Julie, just a year before Morisot died.

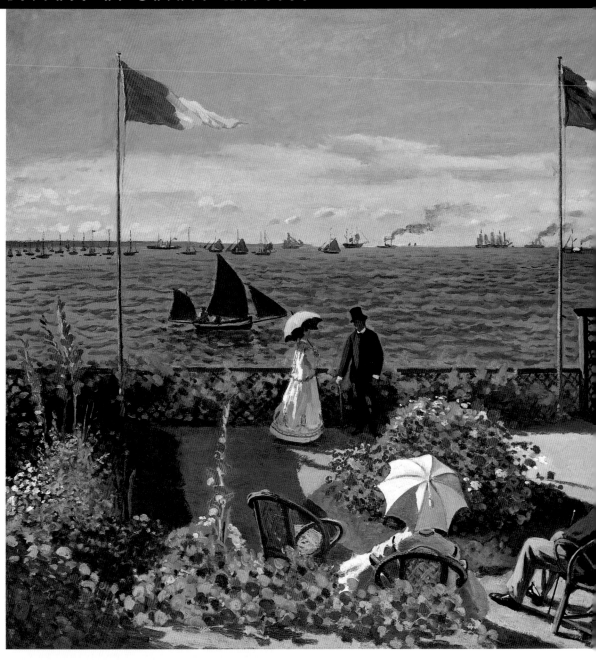

TERRACE AT SAINTE-ADRESSE, 1867, oil on canvas, 39" x 51"
(98 x 130 CM), Metropolitan Museum, New York, U.S.A.

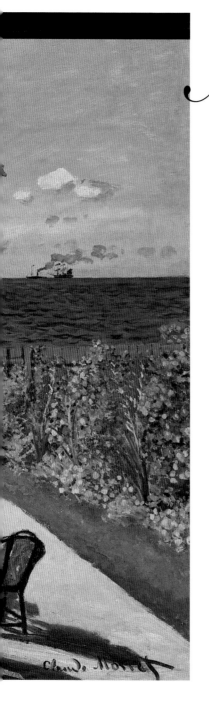

onet painted his family in the garden of his aunt's summer house at the French seaside town of Sainte-Adresse. Monet's father sits looking out at ships in the English Channel, with Monet's aunt seated beside him.

Symbolic sailboat

Artists often reveal their state of mind in their paintings. The dark sailboat in the background of this sunny vacation scene is like the dark cloud hanging over Monet: his money problems. At this point few people would spend any money at all for one of his paintings. Unable to support himself and the woman he wanted to marry, he came home to live with his family for awhile. His father did not approve of his choice of career, but his aunt, who was an amateur painter, believed in him and gave him much encouragement.

Manet or Monet?

"Who is this Monet whose name sounds like mine and who is taking advantage of my fame?" This was Edouard Manet's initial reaction to Monet, who was still a young artist just beginning to be noticed. Manet was irritated at the attention Monet was getting and the confusion their names caused. Even art critics would credit one painter for the work of the other. The two artists finally met and became good friends. They often went out painting together, setting up their easels side by side.

I would like to paint the way a bird sings.

— *Claude Monet*

Claude

*M*onet painted this misty sunrise from a hotel window that looked out upon the harbor of Le Havre, one of the busiest seaports in France. In the dim morning light, you can see smokestacks and the masts of a sailing ship reflected in the water.

Impressionist insults

The Impressionists got their name from an art critic who disliked their work. In 1874, Louis Leroy attended the first independent art exhibition in which Monet, Renoir, Degas, Morisot, Pissarro and others exhibited their paintings. In his nasty review of Monet's *Impression, Sunrise*, he wrote, "Wallpaper in its embryonic state is more finished than this landscape." He went on to call them all "impressionists." Even though the critic meant to insult them, the artists liked the term and were soon using it themselves. Monet said, "I am, and always will be, an impressionist."

I adore the sea, but I know that to do her justice you have to view her every day, at all hours, from the same vantage point, to learn how she lives.

— *Claude Monet*

Claude

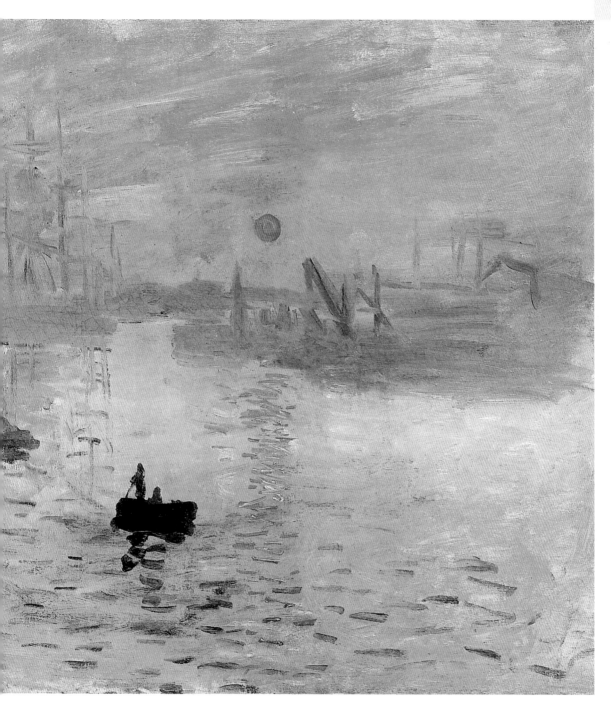

IMPRESSION, SUNRISE, 1872-1873, oil on canvas, 19" x 25"
(48 x 63 CM), Musée Marmottan, Paris, France.

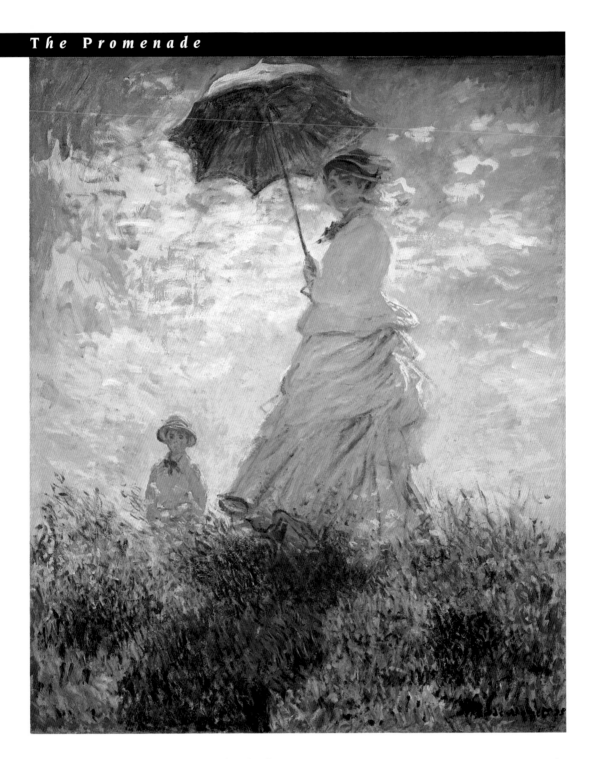

Monet believed the goal of the Impressionists was to ensnare the light and throw it directly on the canvas.

— *Jean Renoir, the son of Auguste Renoir*

This is a painting of Monet's wife, Camille, and their son, Jean, on a bright summer day in the French countryside. Monet and his family were still very poor at this point. The artist would often take his mind off his terrible money worries by creating a beautiful painting.

Open air studio

"Perhaps you would be so kind as to show me to your studio?" asked an editor who had come to interview Monet. At the sound of that word, sparks flew from Monet's eyes. "My studio! But I have never had one, and personally I don't understand why anybody would want to shut themselves up in some room." With a sweeping gesture that encompassed the countryside all around him, the hills, river and fields of wild flowers, he said, "This is my studio!"

Light touches

Monet painted the edges of Camille's dress in bright white. This gives the impression that the sun is shining from behind and it helps her dress stand out against the pale blue sky. With just three light brushstrokes across her face, Monet created the impression of a veil being blown by the wind.

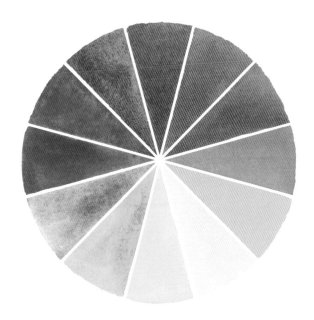

THE PROMENADE, 1875, oil on canvas, 39" x 32" (100 x 81 CM), National Gallery, Washington, D.C., U.S.A.

Chevreul's color wheel

Michel Chevreul discovered that colors look different depending on what they are next to. One color can make another appear brighter or duller. On his color wheel, he placed pairs of colors that contrast the most (such as red and green) opposite one another. Here, the yellow flowers look brighter in front of the violet skirt because they are in contrasting colors.

Claude Monet

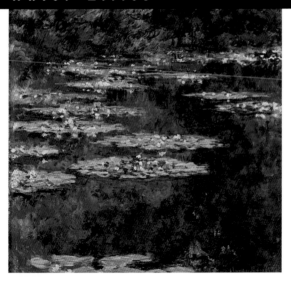

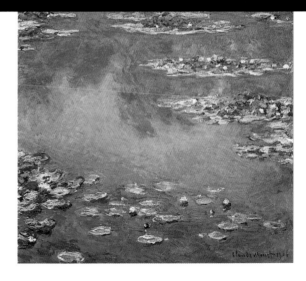

WATER LILIES, 1904, oil on canvas, 35" x 37" (89 x 95 CM),
Musée des Beaux-Arts André Malraux, Le Havre, France.

WATER LILIES, 1906, oil on canvas,
35" x 37" (88 x 93 CM), Art Institute of Chicago, U.S.A.

When the sun rose higher in the sky, went behind the clouds, or began to set, Monet put aside one partly-painted canvas and picked up another. Each one captured a particular effect of light on the lilies and the pond.

Monet did many series paintings — of poplar trees, a cathedral, wheat stacks and sea cliffs. Each series shows us that the things we see do not have fixed colors. Their colors change as the light in which we see them changes.

*A*fter more than twenty years of struggling to support himself and his family, Monet finally achieved fame and financial success. In 1883, he was able to move his family to a wonderful house in the village of Giverny. A great lover of flowers, Monet laid out a huge garden and created a lily pond nearby. For the last thirty years of his life, he painted the pond over and over again, at different times of day and in different seasons.

Claude

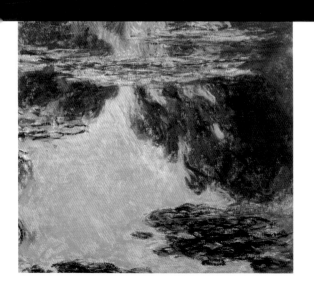

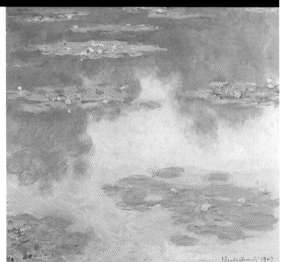

WATER LILIES, 1907, oil on canvas, 39" x 29" (100 x 73 CM), Musée Marmottan, Paris, France.

NYMPHEAS, WATER LANDSCAPE, 1907, oil on canvas, 32" x 36" (81 x 92 CM), Wadsworth Atheneum, Hartford, U.S.A.

When Monet painted the lily pond, he did not paint the water first and then add lilies. He interwove the different elements of the pond. The colors of the water are both under and overlap the green of the lily pads.

Monet once advised another artist, "Try to forget what object you have before you — a tree, a house, a field, or whatever. Merely think, here is a little square of blue, here is an oblong of pink, here a streak of yellow…"

Monet's grand masterpiece

After making over fifty paintings of his lily pond, Monet decided he wanted to decorate an entire gallery with huge water lilies that would completely surround visitors. The French government remodeled two rooms at the Orangerie Museum in Paris especially for Monet's *Grandes Décorations*, as he called them. Some of the paintings were to be nearly fifteen feet (4.5 meters) long! By then, he was over eighty and had outlived his second wife and all his Impressionists friends. He was losing his eyesight, but he continued to paint. More than sixty years after he began painting, he created the masterpiece of his life.

Everyone discusses my art and pretends to understand, as if it were necessary to understand, when it is simply necessary to love.

— Claude Monet

After a morning of boating, a group of Renoir's friends gather for lunch on an island in the Seine River, just outside Paris. The woman playing with a small dog is Aline, Renoir's future wife. The artist Gustave Caillebotte is seated in the lower right. As with all Renoir's work, there is nothing dark, sinister or sad in the painting. Life is portrayed with rosy colors.

Lively glances

Look at one person in this painting, then notice where your eye goes next. You may find you want to follow that person's gaze. By painting so many people looking this way and that, Renoir keeps our eyes moving. This adds to the lively quality of the painting.

A language of hands

Renoir's son, Jean, recalled that his father used to judge people he saw for the first time by their hands. "Did you see that fellow, the way he tore open his package of cigarettes? He's a scoundrel. And that woman — did you notice the way she brushed back her hair with her forefinger? A good girl." Sometimes he labeled them "stupid hands," "witty hands," or "ordinary hands." His own hands were unbelievably small for a man.

In the 1840's, metal paint tubes were invented, like the ones used today. These allowed artists to carry their paints with them outdoors. Before then, oil paints were stored in little pouches made from pigs' bladders!

Auguste Renoir

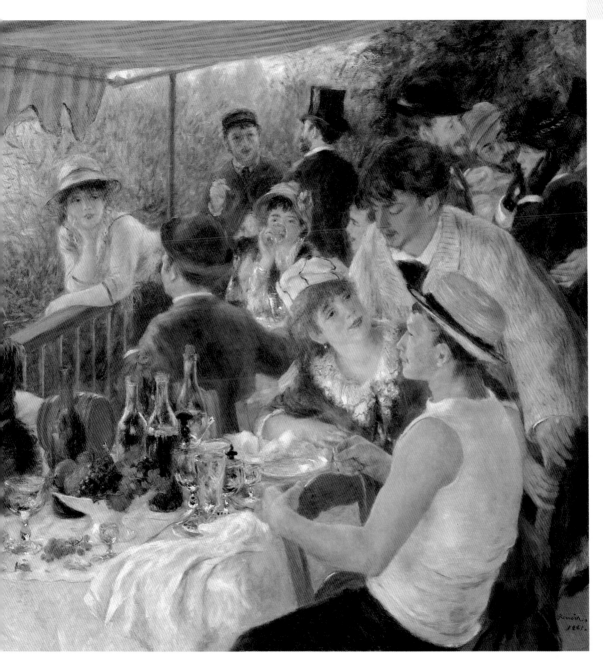

LUNCHEON OF THE BOATING PARTY, 1881, oil on canvas, 51" x 69" (130 x 176 cm), Phillips Collection, Washington D.C., U.S.A.

A couple dances at an outdoor café in Bougival, a small town near Paris. Thanks to the recent invention of trains, people could easily leave Paris to spend a day in the country, boating on the Seine, picnicking or going dancing.

Poor but happy childhood

When Renoir was a boy, his large family lived in a tiny Paris apartment not far from the Tuileries Palace, the residence of King Louis Philippe of France and his queen. Renoir and his friends often played "cops and robbers" and other games, yelling and carrying on in the courtyard just below Queen Marie Amélie's window. Every now and then, she would throw a handful of sweets down to the boys, probably hoping they would quiet down for a bit!

The apartment was so small Renoir referred to it as a "pocket handkerchief." There was no space for him in the boys' bedroom so each night his father spread a mat for him on the tailor's bench in his workroom. Since paper was scarce, Renoir used his father's tailor's chalk to draw on the floor all over the apartment. His father became annoyed when his chalk disappeared but he thought his son's sketches were "not at all bad." Renoir was just thirteen years old when he first went to work as a porcelain painter's apprentice.

Swirling skirts

Renoir creates the impression of a swirling skirt by blurring the edges of the dancer's petticoat. Compare her hem with the one in *The Umbrellas* on the following page. The young woman's sharply painted skirt looks still while the dancer's blurry one appears to be moving.

Painter of happiness

After struggling in poverty for years, Renoir finally achieved acclaim as an artist. But his suffering then took a new form. He developed a crippling arthritis. After years of getting slowly worse, he lost the ability to walk or even pick up a paint-brush. When he wanted to paint, someone would have to place a brush in his stiff hands. But in spite of all his personal hardships, Renoir remained all his life "the painter of happiness."

DANCE AT BOUGIVAL, 1883, oil on canvas, 72" x 39" (182 x 98 CM), Museum of Fine Arts, Boston, U.S.A.

Auguste Renoir

I want my red to sound like a bell. If I don't manage it at first, I put in more red, and also other colors, until I've got it.

— Auguste Renoir

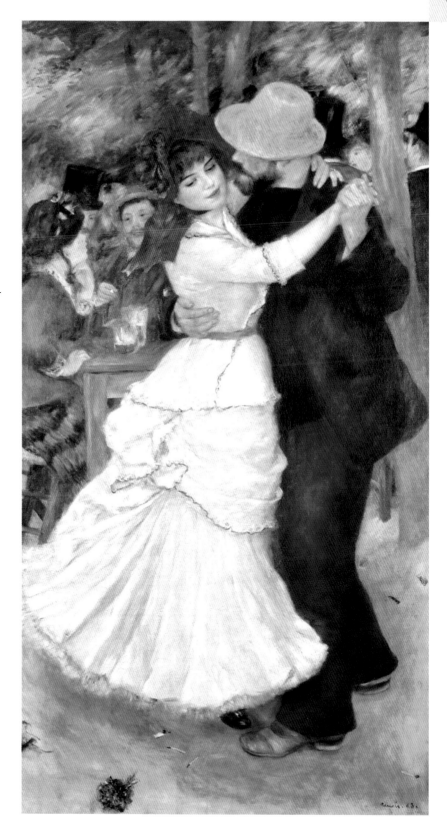

*A*fter more than twenty years as an artist, Renoir felt compelled to change his style. He later recalled "I had followed Impressionism to the utmost limits and was forced to come to the conclusion that I could neither paint nor draw. I had reached a dead end." Renoir traveled to Italy to study the works of Raphael and other great Renaissance masters, then he began to experiment with new ways to paint.

Combining styles

Renoir began this painting in his Impressionist style then set it aside for four years. At first, he wanted to capture the momentary effects of light in an impressionistic way. Four years later, he was more interested in painting people with precision and detail. This came to be known as his "dry" style because he used drier paints (oil paints with less oil in them) and the paintings looked less fluid and soft than his earlier ones.

The queen of colors

Some of the other Impressionist painters refused to use black, believing it put a "hole" in the painting, but Renoir loved it. He called black "the queen of colors."

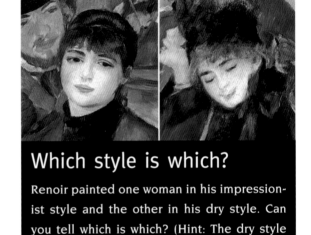

Which style is which?

Renoir painted one woman in his impressionist style and the other in his dry style. Can you tell which is which? (Hint: The dry style looks more "in focus.") Which do you prefer?

THE UMBRELLAS, 1881-1885, oil on canvas, 71" x 45" (180 x 115 CM), National Gallery, London, England.

The public is always convinced you are a fool if you abandon one style to which it is accustomed and adopt another.

— *Auguste Renoir*

Auguste Renoir

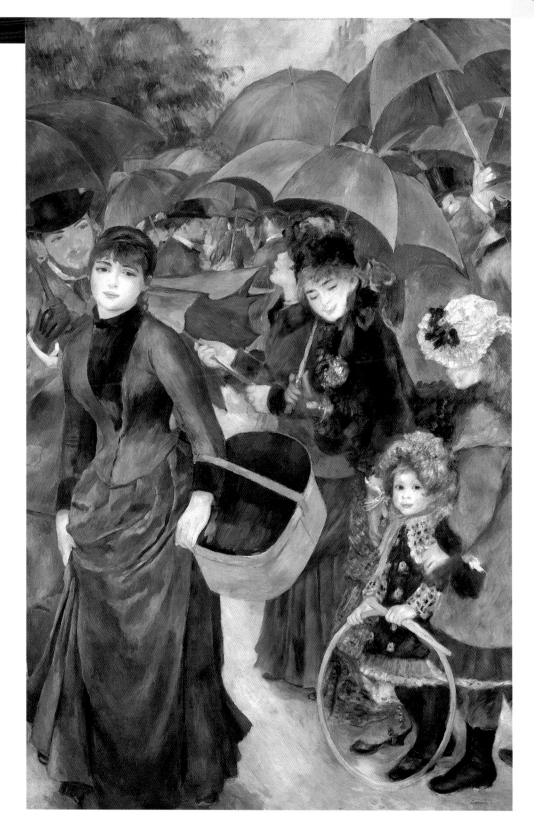

Most well-educated young women learned to play the piano. There was no television, radio, videos or recorded music so families had to create their own entertainment. In the evenings, they would sing and play the piano, or they would read. Friends often got together to play cards and "parlor games" such as charades and riddles.

"My home is your home"

The Impressionists often shared their homes with their artist friends. If Renoir felt an urge to go paint in the country, he thought it perfectly natural to turn up, unannounced, at Claude Monet's or Berthe Morisot's house and get right to work. And he was constantly letting friends use his apartment in Paris.

Animal friends

Renoir liked to go to the Forest of Fontainebleau to paint. The deer were curious about the quiet creature sitting before an easel. One day Renoir fed them some bread and after that he had no peace. They would continually nuzzle him, breathing down his neck. Sometimes he would get mad and shout, "Are you going to let me paint or not?"

Irregular beauty

Renoir believed that natural beauty was never perfectly uniform or symmetrical. He once said, "The works of nature are infinitely varied. The two eyes of the most beautiful face in the world will always be slightly unlike; no nose is placed exactly above the center of the mouth; the quarters of an orange, the leaves of a tree, the petals of a flower are never identical. It seems every kind of beauty draws its charm from this diversity."

Up in smoke

Renoir went through life happy to have few possessions and "just my two hands in my pockets." This extended to his artwork. On cold mornings, he would use his watercolors and drawings to start the fire in his studio stove.

For me a painting should be joyous and pretty — yes, pretty! There are enough annoying things in life without our creating new ones.

— *Auguste Renoir*

Auguste Renoir

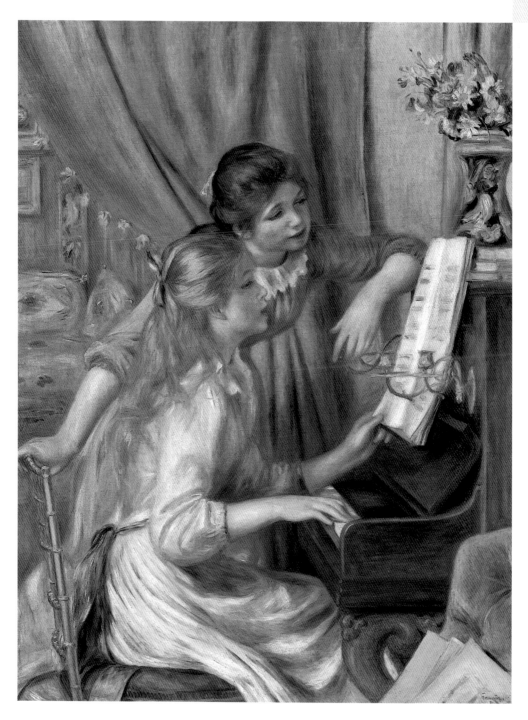

YOUNG GIRLS AT THE PIANO, 1892, oil on canvas,
46" x 36" (116 x 90 CM), Musée d'Orsay, Paris, France.

Cassatt painted this little girl sprawled in an armchair, looking a little bored.

Earlier artists usually painted young girls dressed up and posed like "little ladies." Cassatt preferred to paint them as they really were — each one with a distinct personality. This was a revolutionary thing to do in the 1800's, when few people thought of children as individuals with their own deep thoughts and feelings.

Turning point

Mary Cassatt lived in Paris for three years before she met any Impressionist artists. One day, Degas saw a painting of hers and declared, "Here is someone who feels as I do." When Cassatt first saw one of Degas' paintings on display at an art dealer's shop, she flattened her nose against the shop window to absorb all she could, and returned again and again to see it. Finally Degas paid Cassatt a visit and urged her to exhibit with the Impressionists. She later remembered, "I accepted with joy. I hated conventional art. I began to live." Cassatt considered this meeting the turning point in her life and in her art.

I love to paint children. They are so natural and truthful.

— Mary Cassatt

Mary Cassatt

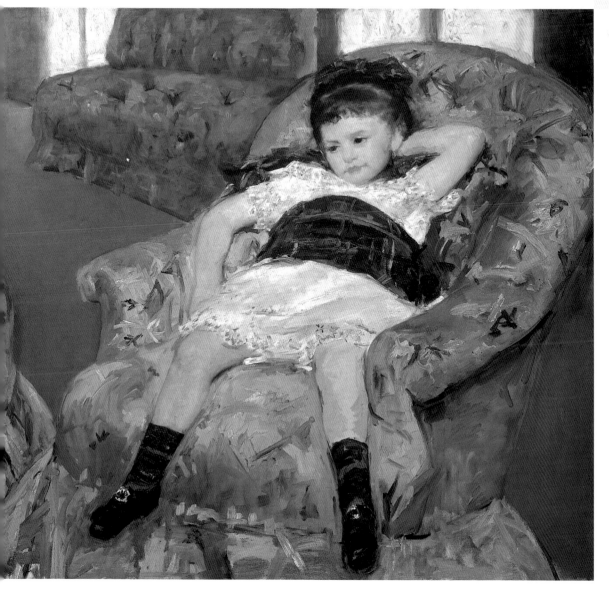

Choosing between love and art

Degas and Cassatt began a close friendship
that lasted over forty years. They had much in
common: Both artists were strong-willed,
independent and intensely involved with their
work. And both placed art before love and
marriage. Degas once said, "There is love and
there is creative work; but a man has only
one heart."

LITTLE GIRL IN A BLUE ARMCHAIR, 1878, oil on canvas,
35" x 51" (90 x 130 CM), National Gallery, Washington, D.C., U.S.A.

*T*his is a portrait of Mary Cassatt's sister, Lydia, who is sitting in a box at the opera, called a loge. The mirror behind her reflects other audience members looking down towards the stage from their opera boxes. Well-to-do Parisians usually went to the theater once or twice a week, attending plays, ballets, concerts and the opera.

See and be seen at the opera

The opera was an important place to "see and be seen." Opera glasses (small binoculars) were used to watch performers on stage, and also to take discreet peeks at people in the audience. Ladies' fans served two purposes: to cool off in a warm theater, and to hide behind.

Fashion rules

This is an evening performance; we can tell by the dress Lydia is wearing. Women wore dark dresses with high necklines to matinees and gowns like this in the evening. What people of the upper class wore for different social occasions was strictly dictated. Ladies and gentlemen carefully obeyed the fashion rules of their day.

How to paint light

"Clean" bright colors, used next to darker, mixed ones ("dirtier" colors), create the three-dimensional effects of highlight and shadow. Cassatt used pale yellow for light falling on Lydia's hair, and a bright, clean red (a red without other colors mixed in) to create the effect of light falling on the red velour seat back. And to make Lydia's pearls glimmer, Cassatt used touches of bright white paint.

LYDIA IN A LOGE, WEARING A NECKLACE, 1879, oil on canvas, 32" x 23" (80 x 58 CM), Philadelphia Museum of Art, U.S.A.

Mary Cassatt

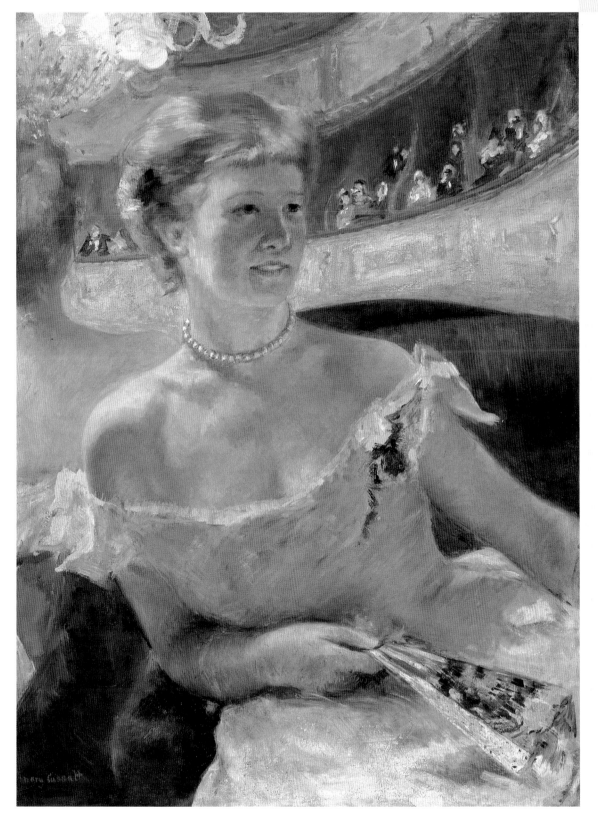

*I*n the 1800's, European ladies and gentlemen often wrote several letters each day. The telephone was not invented until 1876 and did not appear in homes until many years later. Instead of using the phone, people wrote letters to invite friends to dinner or just to chat. In Paris and other large cities, the mail was delivered twice a day so a person could write a letter in the morning and receive a reply by afternoon.

Japanese influence

In 1890, there was an exhibition of Japanese prints in Paris. Mary Cassatt was so amazed by what she saw that she wrote to Berthe Morisot, "You couldn't dream of anything more beautiful. You must see the Japanese — come as soon as you can." The exhibit inspired Cassatt to make a series of color prints of different moments in women's daily lives. She was so influenced by the Japanese art she had seen that she drew the women in her prints with Asian features.

"Bare bones" printmaking

To begin a print, Cassatt etched a line drawing onto a copper plate with a sharply pointed tool. If she made a mistake, she had to start all over again. She then spread black ink on the plate and wiped it off so the only ink left was in the grooves. The printing press then transferred the line drawing to paper, making a "drypoint" print. Cassatt loved the challenge of this kind of print-making. She once said, "In drypoint, you are down to the bare bones. You can't cheat."

Cassatt then used a printmaking technique called "aquatint" to add colors to the drawing. She made five copper plates — one for each color in the picture. First, she covered each copper plate with wax wherever she did not want a particular color to be. Then she dipped the plate in acid, which ate away at the exposed copper, making "traps" to hold the colored ink.

After she removed the wax, each plate was ready to be inked up to print a single color onto the line drawing. Each plate had to be perfectly lined up with the drawing to get the colors in exactly the right places.

THE LETTER, 1890-91, dry point and aquatint print, 14" x 9" (35 x 23 CM), National Gallery, Washington, D.C., U.S.A.

Mary Cassatt

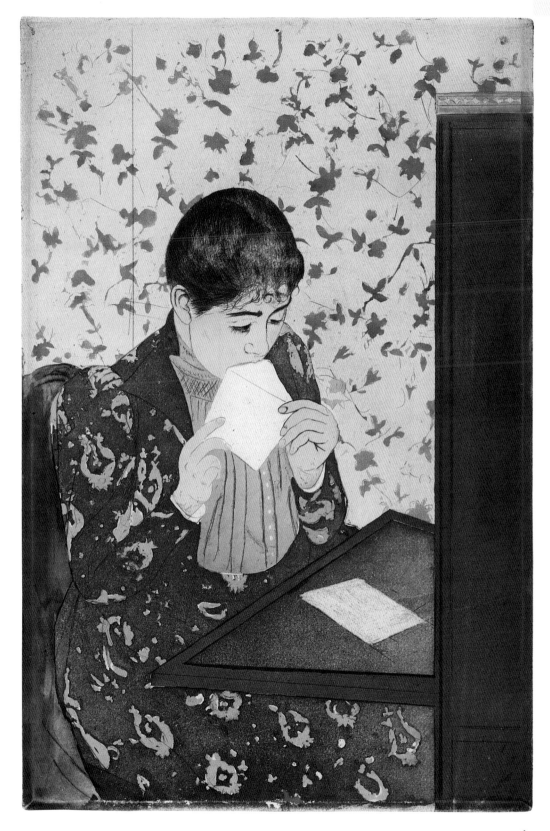

Artists have long believed that the eyes are windows on the soul. Mary Cassatt had a particular talent for revealing a person's personality and state of mind in the expression of their eyes. At a time when men's paintings of women and children focused primarily on their physical beauty, Cassatt painted them with a beauty that shines from within.

A B C

What color is white?

Mary Cassatt used many colors to create the impression of light and shadow on the white sheets, clothing and coffee cup. The cup is painted a cool blue-white with touches of lavender, the shadows on the pillow are made with blues and greens, and the little girl's shirt has pink and yellow mixed in with the white. Can you find each of these different whites in the painting? How do they compare with the pure white of this page?

A. The coffee cup B. The child's shirt C. The pillow

Mary Cassatt feels strongly that the place of the child in life is of limitless importance.

— Achille Segard, French art critic

Mary Cassatt

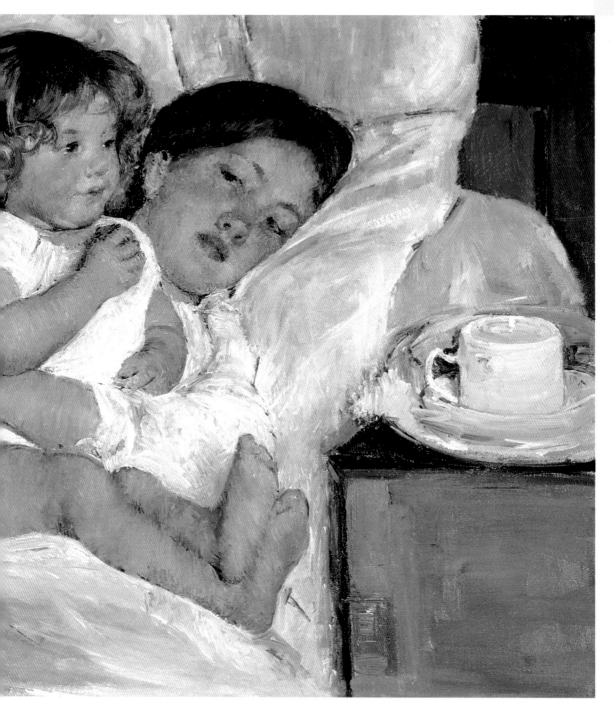

BREAKFAST IN BED, 1897, oil on canvas, 26" x 29" (65 x 74 CM),
Huntington Library and Art Gallery, San Marino, U.S.A.

These men are finishing a floor. They are scraping away the top layer of wood so each board is level with the one next to it and the entire floor is smooth and even. The man on the right is running a planing tool over each crack, which makes a striped pattern on the floor. The man in the middle is scraping away an even finer layer of wood, while the man on the left reaches for a file to sharpen his scraping tool.

Two kinds of curlycue

The curly wood shavings echo the shapes in the balcony railing outside the window. Artists often use similar shapes to visually connect different parts of a painting.

Three men or only one?

Do these men look alike to you? Caillebotte probably painted one man in three different positions. This adds to the unity of the painting since there are repeated images of the same long arms and slender body. Imagine how different the painting would look with three very different workers.

Gustave Caillebotte

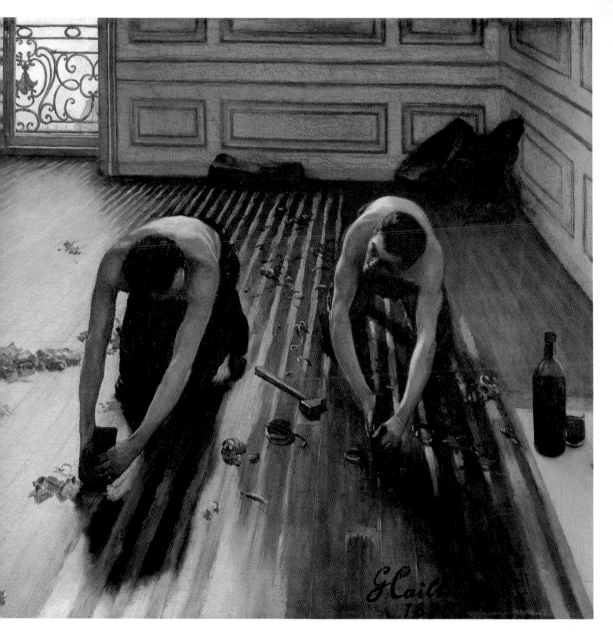

Beautiful bodies

Caillebotte wanted to celebrate the beauty of men at work in the modern world, but the public was shocked. They were used to seeing paintings of Greek gods and heroes, not simple laborers of their own time. One critic wrote, "The subject is doubtless vulgar." Another called it "ugly" and a third found it "strange and rather unpleasant."

THE FLOOR SCRAPERS, 1875, oil on canvas, 40" x 57" (100 x 145 CM), Musée d'Orsay, Paris, France.

*L*ike the other Impressionists, Caillebotte was interested in capturing everyday scenes of modern life. In spite of his brilliant artwork, not everyone took him seriously as an artist. One critic of the time described him as "a millionaire who paints in his spare time."

Two self-portraits in one painting

Artists often depict themselves in a painting, but in this one Caillebotte probably painted himself twice, showing two different aspects of his life. The man in the top hat looks like Caillebotte as a wealthy gentleman, while the worker leaning on the railing looks like Caillebotte as a hard-working artist. Unlike most rich gentlemen, Caillebotte worked with his hands. In addition to painting, he designed and built racing boats. He also loved to garden, a passion he shared with his friend, Claude Monet.

A helping hand

When Monet, Pissarro and other artists needed money, they often turned to Caillebotte. He loaned them money, bought their paintings and promoted their work to others. For one of their exhibitions, he found the exhibit space, sent out invitations, helped hang the pictures and paid for the publicity. He also donated his art to an Impressionist fundraiser. When few people bought any paintings, Caillebotte bought several, including some of his own!

The Europe Bridge crosses over the tracks behind the St. Lazare train station in Paris. The six streets that come together at the bridge are named for different European cities. That's how the bridge got its name.

Gustave

THE EUROPE BRIDGE, 1876, oil on canvas, 49" x 71"
(125 x 181 CM), Musée du Petit Palais, Geneva, Switzerland.

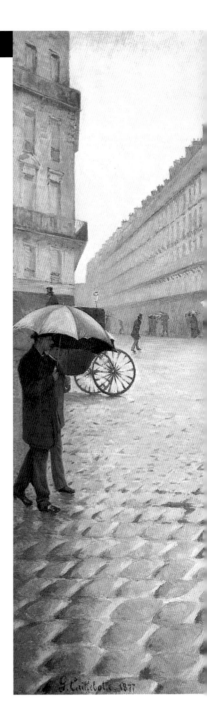

*T*his picture may look old-fashioned, but when it was painted it was thoroughly modern. All the buildings and the wide boulevards were recently built. The gas street lamp was a new invention, and even umbrellas were modern. They had been invented just three years before Caillebotte painted this picture.

Sleepwalkers

At first glance, this is a charming scene, but look again. The people in the background seem like sleepwalkers. Almost everyone is dressed in black, with gray umbrellas. They walk on a street that is entirely man-made, with not a single tree or blade of grass. Caillebotte painted all the buildings with a sameness about them. His painting suggests that modern life in the newly rebuilt Paris was somewhat cold and impersonal. Only the two figures in the foreground give the painting a human touch.

Where's the rain?

You can see water between the cobblestones in the street and glistening on the sidewalk, but no raindrops appear to be falling. One mocking critic quipped, "The rain seems to have made no impression on Monsieur Caillebotte." Why do you think he painted people with open umbrellas, but no rain? Could a light, almost invisible mist be falling?

Gustave Caillebotte

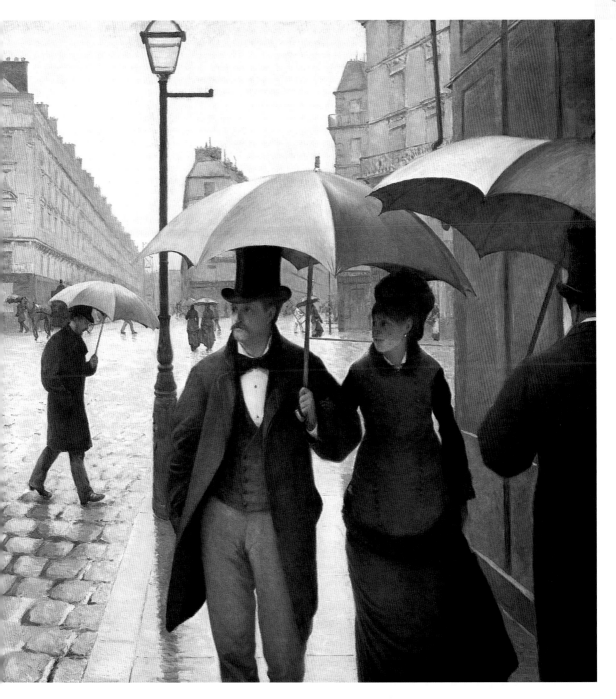

Unseen feet

Caillebotte has painted a lady and gentleman walking towards us, but he has cut them off below the knees. It almost seems as if their unseen feet are outside the painting, right in front of us.

PARIS, A RAINY DAY, 1877, oil on canvas, 84" x 109"
(212 x 276 CM), Art Institute of Chicago, U.S.A.

*R*owing was a fairly new sport in France. Boating clubs had recently sprung up along the Seine River. Gustave Caillebotte and his brother, Martial, both boating enthusiasts, competed in weekend races, and often won.

Role of photography

Caillebotte probably used a photograph to make his initial sketches for *The Oarsmen*. The Impressionists were the first artists to use the new technology of photography to help them with their paintings.

Gift to France

Caillebotte died young and left his large collection of Impressionist paintings to France, on the condition that they be exhibited in the great museums of Paris, not stuck in a storeroom. This was his last effort to get recognition for the Impressionist artists who were his friends. Amazingly, the museums refused to accept nearly half of the 67 paintings he left them. But thanks to his gift, such great paintings as Manet's *The Balcony* and his own *Floor Scrapers* are now hanging in the Musée d'Orsay in Paris, for all to enjoy.

A new way of seeing

Caillebotte was the youngest of these eight Impressionist artists, though Cassatt and Monet outlived him by more than thirty years. Each artist had a distinct style of painting, but together they showed us a new way of seeing and changed the world of art forever.

Gustave Caillebotte

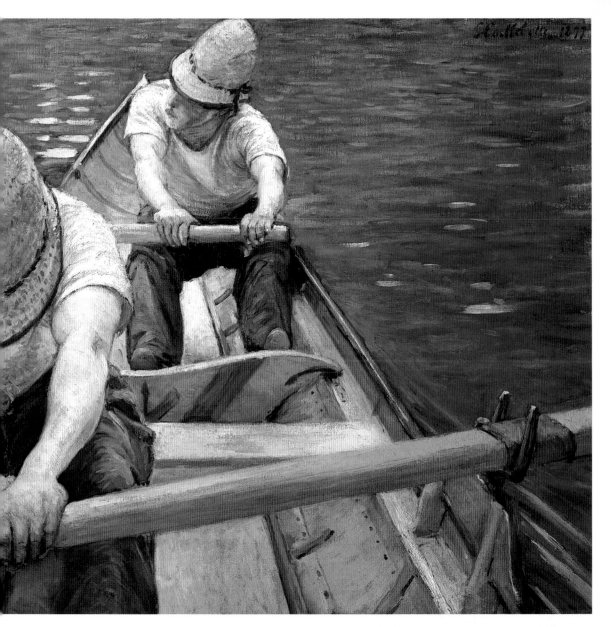

To name an object is to suppress
three-quarters of the enjoyment
...To suggest it, that is the dream.

— Stéphane Mallarmé,
poet and friend of the Impressionists

THE OARSMEN, 1877, oil on canvas, 32" x 46" (81 x 116 CM),
Private Collection, Paris, France.

Bibliography

Adler, Kathleen & Garb, Tamar. *Berthe Morisot*. London: Phaidon, 1987.

Adler, Kathleen. *Impressionism*. London: National Gallery Publications, 1999.

Becker, Christoph (ed.). *Camille Pissarro*. Ostfildern, Germany: Hatje Cantz, 2000.

Cachin, Françoise. *Manet: The Influence of the Modern*. New York: Harry N. Abrams, 1995.

Denvir, Bernard. *The Chronicle of Impressionism*. London: Thames & Hudson, 1993.

Distel, Anne et al. (eds.). *Gustave Caillebotte: Urban Impressionist*. New York: Abbeville, 1995.

Distel, Anne. *Renoir: A Sensuous Vision*. New York: Harry N. Abrams, 1995.

Gruitrooy, Gerhard. *Renoir: A Master of Impressionism*. New York: Todtri, 1994.

Hagen, Rose-Marie & Hagen, Rainer. *What Great Paintings Say*. Köln: Taschen, 2000.

Higonnet, Anne. *Berthe Morisot*. New York: Rizzoli International, 1993.

Kapos, Martha (ed.). *The Impressionists: A Retrospective*. London: Hugh Lauter Levin, 1991.

Katz, Robert & Dars, Celestine. *The Impressionists*. New York: Barnes & Noble, 1994.

Loyrette, Henri. *Degas: The Man and His Art*. New York: Harry N. Abrams, 1993.

Mancoff, Debra N. *Mary Cassatt: Reflections of Women's Lives*. London: Frances Lincoln, 1998.

Mathews, Nancy M. *Mary Cassatt: A Life*. New York: Villard, 1994.

Moffett, Charles S. (ed.). *The New Painting: Impressionism 1874-1886*. San Francisco: The Fine Arts Museums of San Francisco, 1986.

Morris, Catherine. *The Essential Claude Monet*. New York: Harry N. Abrams, 1999.

Patin, Sylvie. *Monet: The Ultimate Impressionist*. New York: Harry N. Abrams, 1991.

Pissarro, Joachim. *Camille Pissarro*. New York: Harry N. Abrams, 1993.

Pollock, Griselda. *Mary Cassatt: Painter of Modern Women*. London: Thames & Hudson, 1998.

Renoir, Jean. *Renoir, My Father*. Boston: Little Brown, 1958.

Shennan, Margaret. *Berthe Morisot: First Lady of Impressionism*. Gloucestershire: Sutton, 2000.

Sporre, Dennis. *The Creative Impulse: An Introduction to the Arts*. Upper Saddle River: Prentice Hall, 1996.

Varnedoe, Kirk. *Gustave Caillebotte*. New Haven: Yale University Press, 1987.

White, Barbara E. *Impressionists Side by Side* New York: Alfred A. Knopf, 1996.

Williams, Ellen. *The Impressionists' Paris*. New York: The Little Bookroom, 1997.

For Young Readers

Björk, Christina. *Linnea in Monet's Garden*. Stockholm: R & S Books, 1987.

Bolton, Linda. *Impressionism*. Chicago: Peter Bedrick, 2000.

Harrison, Peter. *Claude Monet*. New York: Sterling, 1996.

Meyer, Susan E. *Edgar Degas*. New York: Harry N. Abrams, 1994.

Meyer, Susan E. *Mary Cassatt*. New York: Harry N. Abrams, 1990.

Mühlberger, Richard. *What Makes a Degas a Degas?* New York: Viking/The Metropolitan Museum, 1993.

Mühlberger, Richard. *What Makes a Monet a Monet?* New York: Viking/The Metropolitan Museum, 1993.

Rayfield, Susan. *Pierre-Auguste Renoir*. New York: Harry N. Abrams, 1998.

Salvi, Francesco. *The Impressionists: The Origin of Modern Painting*. Chicago: Peter Bedrick, 2000.

Spence, David. *Degas: The Invisible Eye*. Tonbridge, UK: Ticktock, 1998.

Spence, David. *Monet: Impressionism*. Tonbridge, UK: Ticktock, 1997.

Streissguth, Tom. *Mary Cassatt: Portrait of an American Impressionist*. Minneapolis: Carolrhoda, 1999.

Waldron, Ann. *Claude Monet*. New York: Harry N. Abrams, 1991.

Welton, Jude. *Impressionism*. London: Dorling Kindersley, 1993.

Welton, Jude. *Monet*. London: Dorling Kindersley, 2000.

Wright, Patricia. *Manet*. London: Dorling Kindersley, 1993.

For permission to reproduce paintings and archive photographs and for supplying photographs, our thanks to those listed below.

Abbreviations

AI: Archivo Iconografico, S.A. **AIC**: The Art Institute of Chicago **AR**: Art Resource, New York **BAL**: Bridgeman Art Library **B**: Bettman **C**: CORBIS **EL**: Erich Lessing **G**: Giraudon **GDO**: Gianni Dagli Orti **HD**: Hulton-Deutsch Collection **MET**: The Metropolitan Museum of Art, New York **MFA**: Museum of Fine Arts, Boston **MoMA**: The Museum of Modern Art, New York **NGL**: The National Gallery, London **NGW**: National Gallery of Art, Washington **RMN**: Réunion des Musées Nationaux

Our special thanks to the museums that exhibit the works of art reproduced in this book:

In the United States

Museum of Fine Arts, Boston

Metropolitan Museum, New York

Wadsworth Athenium, Hartford, Connecticut

Philadelphia Museum of Art

National Gallery of Art, Washington, D.C.

Phillips Collection, Washington, D.C.

Art Institute of Chicago

Huntington Library and Art Gallery,
 San Marino, California

In Europe

National Gallery, London, England

Courtauld Institute Galleries, London, England

Ashmolean Museum, Oxford, England

Musée d'Orsay, Paris, France

Musée Marmottan, Paris, Fance

Musée Fabre, Montpellier, France

Musée des Beaux-Arts Malraux, Le Havre, France

Thyssen-Bornemisza Collection, Madrid, Spain

Musée du Petit Palais, Geneva, Switzerland

Photography of cover picture frame and art materials throughout the book by Drew Wright.

Cover. Dance at Bougival: MFA/BAL.

2. Place de la Concorde, Paris: B/C. The Last of England: Birmingham Museums and Art Gallery/BAL. Child Labor in a Cotton Mill: C.

3. Bombardment of Paris: GDO/C.

4. Bonaparte Crossing the Alps: AI/C. Battlefield Cartoon: G/AR.

5. Art Students and Copyists in the Louvre: B/C. Itsukushima Moon: Asian Art & Archeology, Inc./C. Minding the Baby: MoMA.

6. Stephenson's Locomotive: GDO/C. Queen Victoria: B/C. Morse's Telegraph: B/C. Street Fighting During the Austrian Revolution of 1848: AI/C. Birds illustration by John Gould, reproduced by courtesy of The Royal Geographical Society, London. Louis Pasteur Giving an Inoculation: B/C. Battle of Gettysburg: C. Japan Opens to the West: B/C. Macmillan's Bicycle: HD/C. 19th Century Photographer at Work: HD/C. The Steamship Amerigo Vespucci: Araldo de Luca/C. Florence Nightingale: B/C. Burning of Paris in 1871: GDO/C.

7. Alexander Graham Bell: B/C. Karl Benz and his Daughter in Benz Automobile: B/C. Man Using First Movie Camera: HD/C. Marconi's Experimental Apparatus: HD/C. World War I Poster: C. Suffragettes Holding Victory Jubilee: B/C. Wagnerian Opera Singer: B/C. Edison's First Light Bulb: B/C. Eiffel Tower: B/C. Test Flight of Wright Glider: C. Albert Einstein in 1931: B/C. Titanic Sinking: Harley Crossley, Private Collection/BAL.

8. Portrait of Edouard Manet by Henri Fantin-Latour: B/C. Self-portrait, Camille Pissarro: EL/AR. Self-portrait, Edgar Degas: AI/C. Portrait of Berthe Morisot by Edouard Manet: EL/AR.

9. Portrait of Claude Monet by Auguste Renoir, Collection of Mr. and Mrs. Paul Mellon, © 2001 Board of Trustees, NGW. Self-portrait, Auguste Renoir: Courtesy of the Fogg Art Museum, Harvard University Art Museums, Bequest from the Collection of Maurice Wertheim, Class of 1906. Self-portrait, Mary Cassatt: MET, Bequest of Edith H. Proskauer, 1975. (1975.319.1) Photograph © 1998 MET. Self-portrait, Gustave Caillebotte: EL/AR.

10. Tulips, Narcissi, and Other Flowers in a Glass Vase, with a Caterpillar, a Fly and a Painted Lady by Ambrosius Bosschaert I: Christie's Images/C.

11. Peonies in a Vase: EL/AR.

12. Grand Odalisque: EL/AR.

13. The Balcony: EL/AR.

14-15. At the Railway Station: Gift of Horace Havemeyer in memory of his mother Louisine W. Havemeyer, © 2001 Board of Trustees, NGW.

16-17, 1. A Bar at the Folies-Bergère: The Courtauld Gallery, London.

18-19. The Jallais Hills, Pontoise: MET, Bequest of William Church Osborn, 1951.(51.30.2) Photograph © 1997 MET.

20-21. The Crystal Palace: Camille Pissarro, French, 1830-1903, AIC, Gift of Mr. and Mrs. B.E. Bensinger, 1972.1164. All Rights Reserved. London's Crystal Palace during the International Exhibition of 1851: Victoria & Albert Museum, London/AR.

22-23. Peasants Planting Pea Sticks: Ashmolean Museum, Oxford.

25. Boulevard Montmartre at Night: NGL. The Starry Night: MoMA.

26-27. Racehorses Before the Stands: RMN/AR. Bolted! by Thomas Worth: HD/C. Jockey on a Galloping Horse, Plate 627 from "Animal Locomotion," by Eadweard Muybridge: Stapleton Collection, UK/BAL.

28-29. Miss La La at the Cirque Fernando: NGL. Sketch of Miss La La: The Barber Institute of Fine Arts, University of Birmingham/BAL.

31, 1. The Green Dancer: EL/AR.

32-33. Woman Bathing in a Shallow Tub: G/AR.

34. Mother and Sister of the Artist: Chester Dale Collection, © 2001 Board of Trustees, NGW.

37. The Cradle: EL/AR.

38. Summer: EL/AR.

40. Eugène Manet and his Daughter at Bougival: G/AR.

41. Berthe Morisot and Her Daughter Julie: Courtesy of Christie's Images, New York.

42-43, 1. Terrace at Sainte-Adresse: MET, Purchased with special contributions and purchase funds given or bequeathed by friends of the Museum, 1967. (67.241) Photograph © 1989 MET.

44-45. Impression, Sunrise: EL/AR.

46. The Promenade: Collection of Mr. and Mrs. Paul Mellon, © 2001 Board of Trustees, NGW.

48. Water Lilies (1904): G/AR. Water Lilies (1906): Claude Monet, French, 1840-1926, AIC, Mr. and Mrs. Martin A. Ryerson Collection, 1933.1157. All Rights Reserved.

49. Water Lilies (1907): EL/AR. Nympheas, Water Landscape: Wadsworth Atheneum, Bequest of Anne Parrish Titzell.

50-51. Luncheon of the Boating Party: The Phillips Collection, Washington, D.C.

53. Dance at Bougival: MFA. Reproduced with permission. © 2000 MFA. All rights reserved.

55. The Umbrellas: NGL.

57. Young Girls at the Piano: RMN/AR.

58-59. Little Girl in a Blue Armchair: Collection of Mr. and Mrs. Paul Mellon, © 2001 Board of Trustees, NGW.

61. Lydia in a Loge, Wearing a Pearl Necklace: Philadelphia Museum of Art, Bequest of Charlotte Dorrance Wright.

63. The Letter: Chester Dale Collection, © 2001 Board of Trustees, NGW.

64-65. Breakfast in Bed: The Huntington Library, Art Collections, and Botanical Gardens, San Marino, California/Superstock.

66-67. The Floor Scrapers: EL/AR.

68-69. The Europe Bridge: EL/AR. The Pont de l'Europe and the Gare Saint Lazare, wood engraving by A. Lamy, from L'Illustration, 11 April 1868: General Research Division, The New York Public Library, Astor, Lenox and Tilden Foundation.

70-71, 1. Paris, A Rainy Day: Gustave Caillebotte, French, 1848-1894, AIC, Charles H. and Mary F.S. Worcester Collection, 1964.336. All Rights Reserved.

72-73. The Oarsmen: EL/AR.